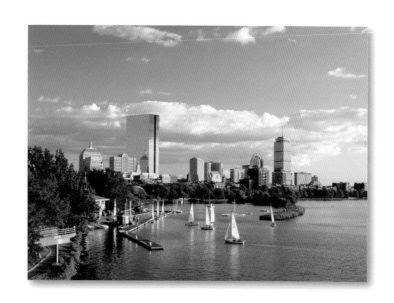

# BOSTON

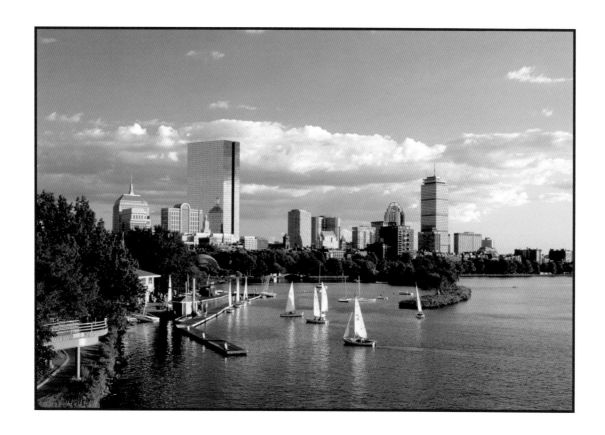

whitecap

Text by Tanya Lloyd Kyi
Edited by Elaine Jones
Photo editing by Tanya Lloyd Kyi
Proofread by Lisa Collins
Cover and interior design by Maxine Lea

Printed and bound in China

**National Library of Canada Cataloguing in Publication Data**

Lloyd, Tanya, 1973–

    Boston

    (America series)
    ISBN 1-55285-255-5
    ISBN 978-1-55285-255-2

    1. Boston (Mass.) —Pictorial works. I. Title. II. Series: Lloyd, Tanya, 1973-
America series.
F732.L56 2001        974.4'61044'0222        C2001-910978-4

The publisher acknowledges the financial support of the Government of Canada through the Book Publishing Industry Development Program (BPIDP) and the province of British Columbia through the Book Publishing Tax Credit.

For more information on the America Series, please visit www.midpointtrade.com.

First John Smith sailed into Massachusetts Bay, then the redcoats arrived, and now millions of sightseers tour Boston each year. The city's population is growing steadily, and a list of past residents reads like a roll call of American culture. John Adams, Ralph Waldo Emerson, Henry David Thoreau, Harriet Beecher Stowe, and Martin Luther King, Jr. have all strolled the streets of Beacon Hill and gazed out over Boston Harbor. What does Boston have that draws so many?

Perhaps the answer lies not in what Boston *has*, but in what Boston *is*. Other cities may claim to be the birthplace of a sport, a product, or an industry. Boston is the birthplace of a nation. A walk on the city's Freedom Trail stops at countless historic sites that speak of inspiration and independence. First is the harbor, where in 1773 residents boarded British ships and dumped crates of tea overboard in the fabled Boston Tea Party. Then the Customs House, where a mob clashed with British soldiers in 1770, resulting in five deaths and helping to incite the American Revolution. Next Faneuil Hall, where Samuel Adams swayed the city to the revolutionary cause and George Washington toasted the new nation on its first birthday.

And just as Boston's past is remarkable, there is much to admire in the contemporary city. The Emerald Necklace, a series of parks designed by Frederick Law Olmstead in the 1800s, beckons city dwellers toward shady paths and beautiful grounds. From downtown's Boston Common and the Public Gardens to the Back Bay Fens and the Arnold Arboretum, this string of green spaces stretches across the city, leading from one unique neighborhood to another.

Conscientious planning has revitalized and preserved many of these neighborhoods. In the North End, Italian markets spill into the lively streets. Stately churches and lush lawns greet Roxbury visitors. High fashion and upscale cafés line the streets of Back Bay, and historic brick row houses lend a quaint air to the South End. In each area of the city—as in each era of Boston history—there is much to discover.

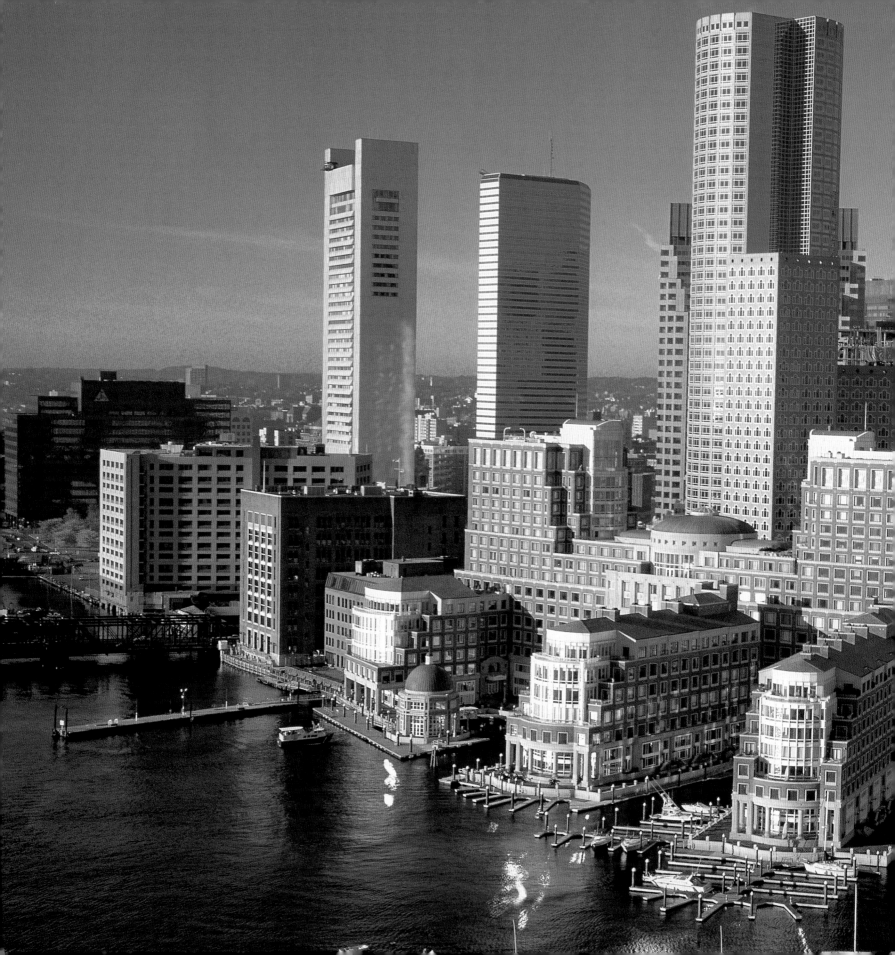

Millions of visitors arrive in Boston each year, contributing billions of dollars to the local economy. Many use the city as a base for exploring Massachusetts and the New England coast.

Once the pasture of William Blaxton, 50-acre Boston Common was bought by the city in 1634. Public grazing was allowed on the land, along with fairs and events—including the occasional hanging. Today the park is one of the highlights of the Emerald Necklace, a chain of green spaces throughout the city.

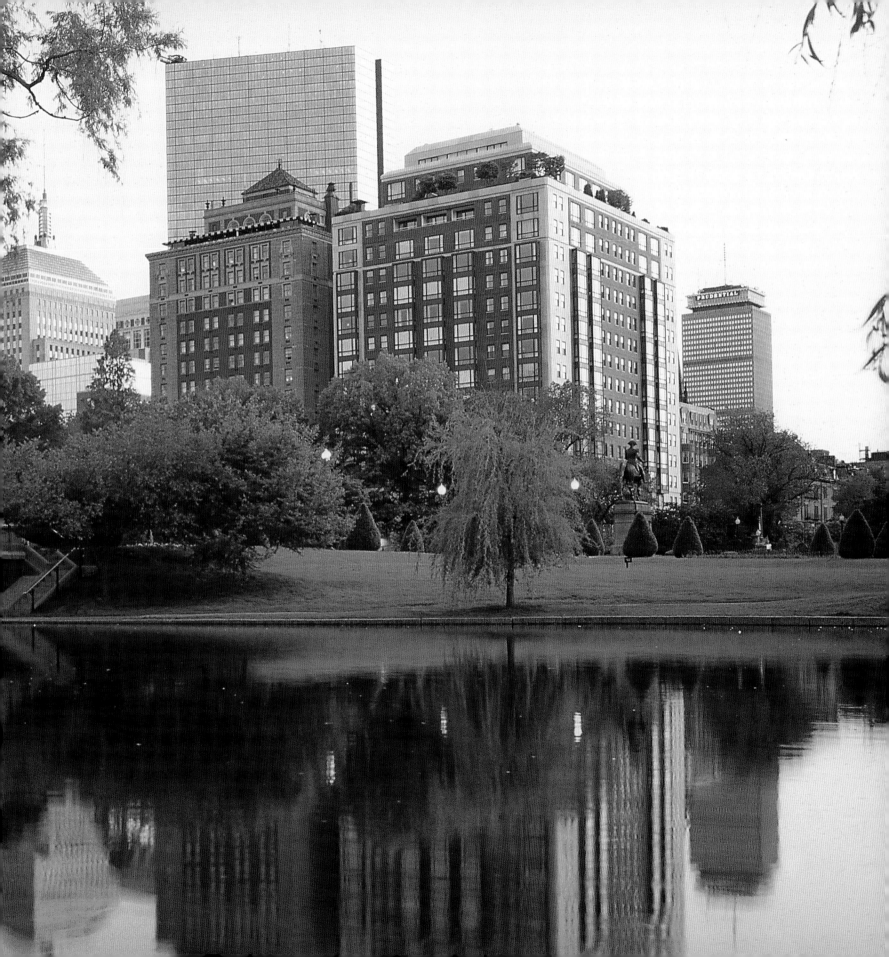

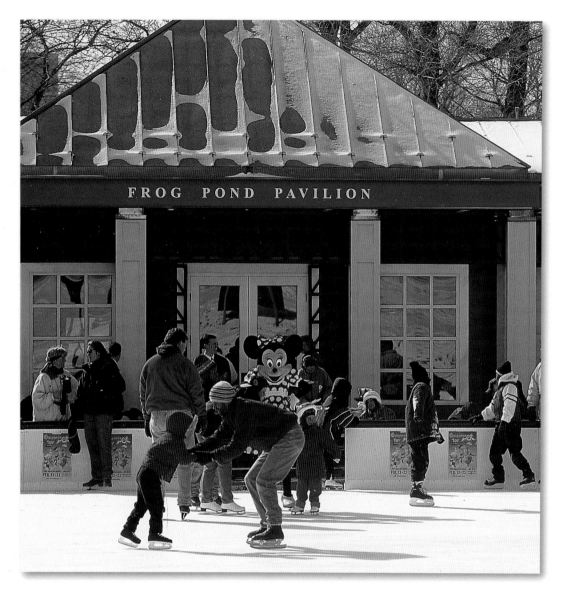

Each November, Boston Common's Frog Pond is transformed into a glistening 16,000-foot rink, tempting the city's children and even the occasional office worker on a lunch break. The nearby kiosk offers skaters hot chocolate.

Architect Charles Bulfinch supervised the creation of the State House in 1798, at the top of Beacon Hill. The gleaming copper dome was originally designed in wooden shingles.

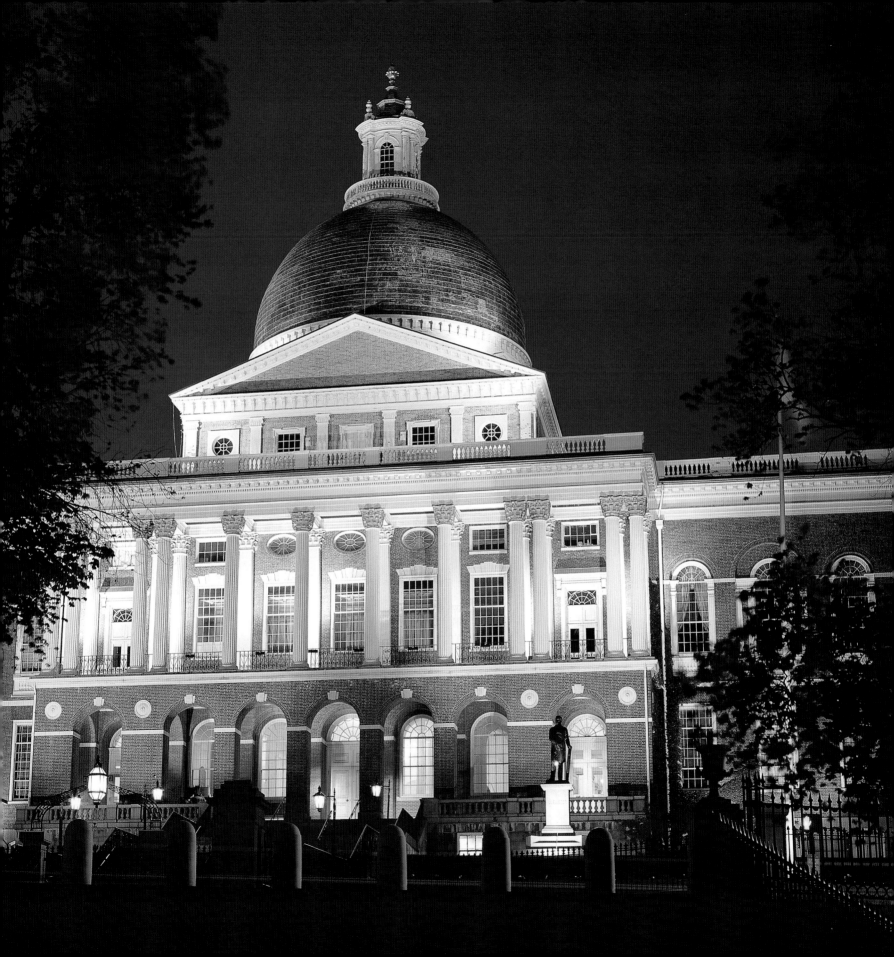

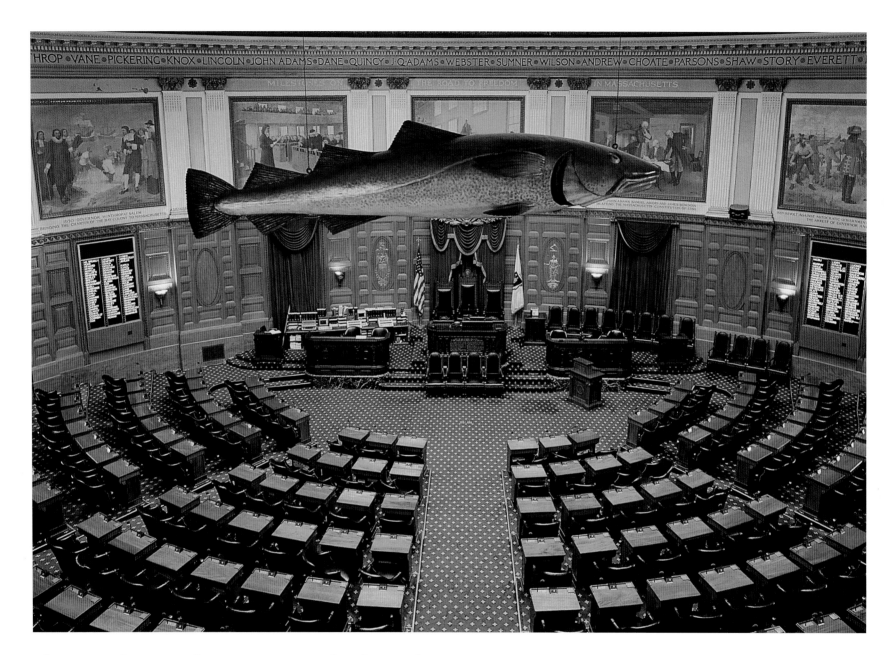

The restored House of Representatives Chamber in the State House
is presided over by the "Sacred Cod," a four-foot-long carved fish.
Businessman John Rowe presented it to the state as a symbol of
Massachusetts' fishing heritage.

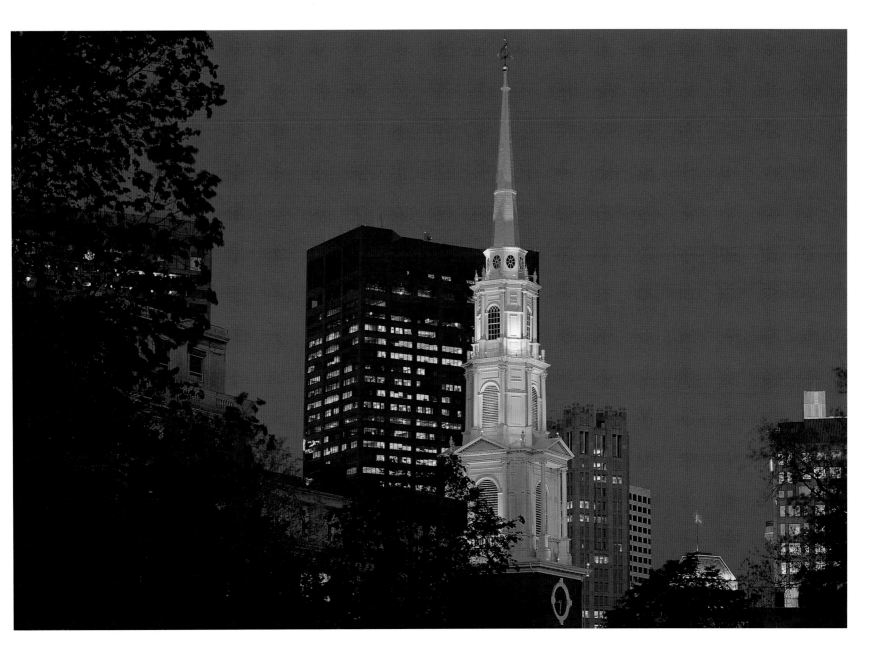

Built in 1809, the Park Street Church features a 217-foot steeple, designed to inspire awe in parishioners below. The burial ground next to the church is the final resting place of Paul Revere.

In 1775, Paul Revere rode from Boston to Lexington, warning of an impending British attack. His journey was immortalized in Henry Wadsworth Longfellow's poem "Paul Revere's Ride."

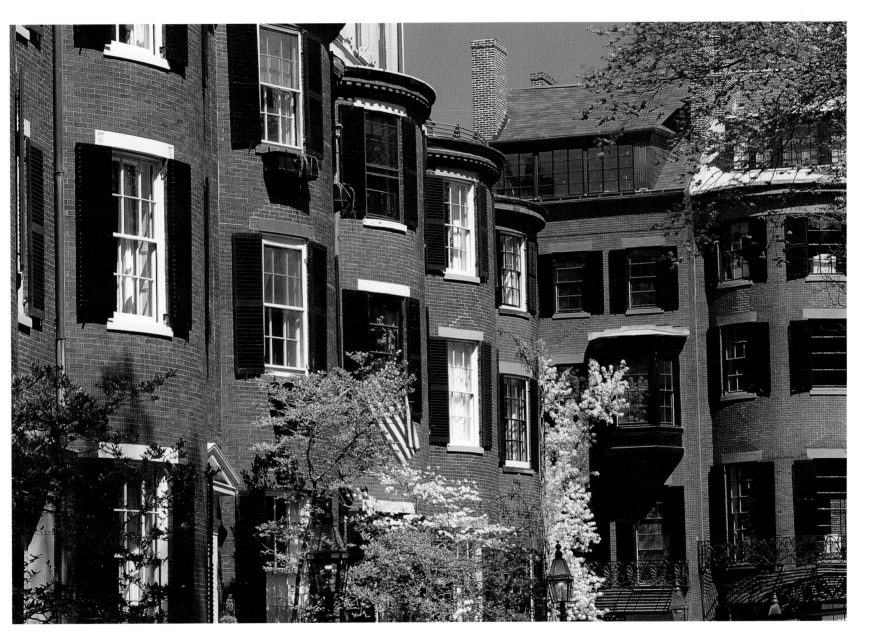

Springtime bedecks Louisburg Square and Beacon Hill in blossoms.
The neighborhood was named for the signal tower that stood atop
the hill in the 1600s to warn residents of impending attacks.

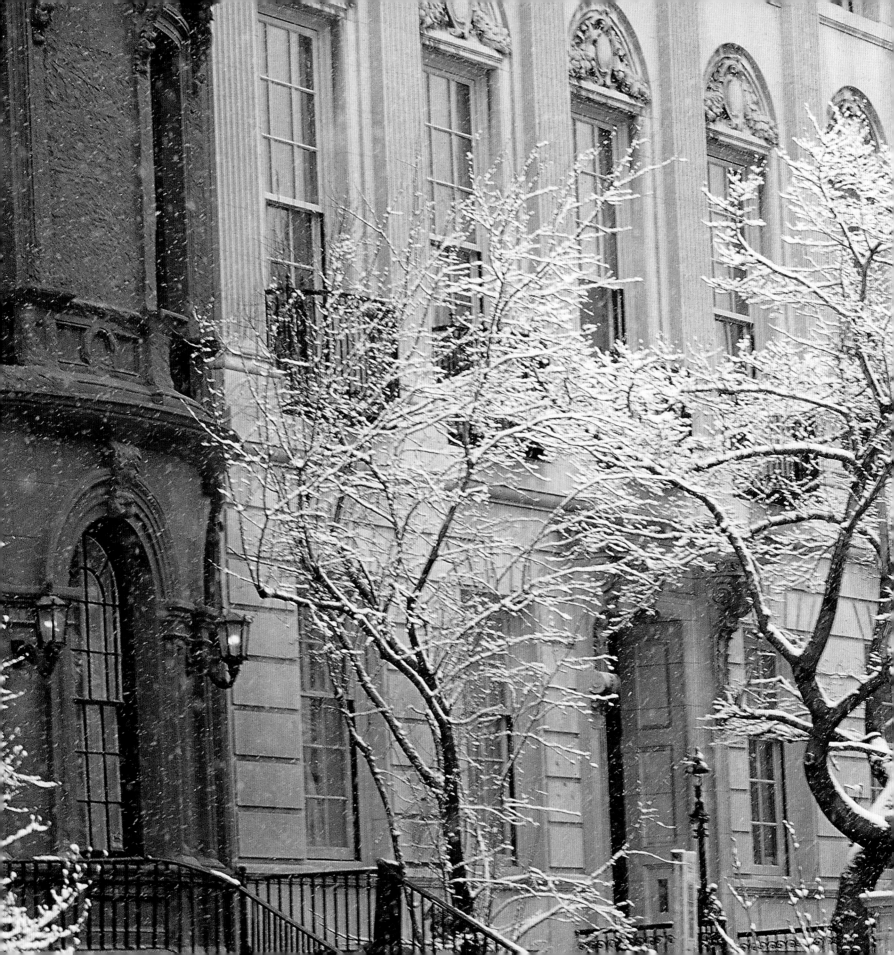

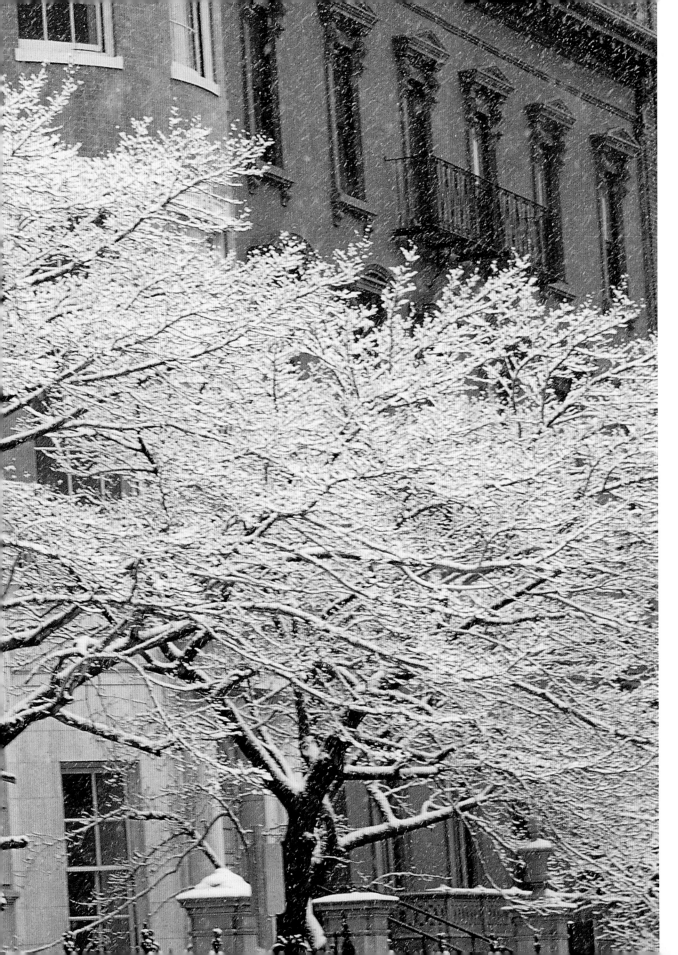

In the late 1700s and early 1800s, Beacon Street was the bastion of Boston's wealthiest families, as well as some of the city's best-known intellectuals. Oliver Wendell Holmes, Henry Wadsworth Longfellow, and Louisa May Alcott all lived in the neighborhood.

17

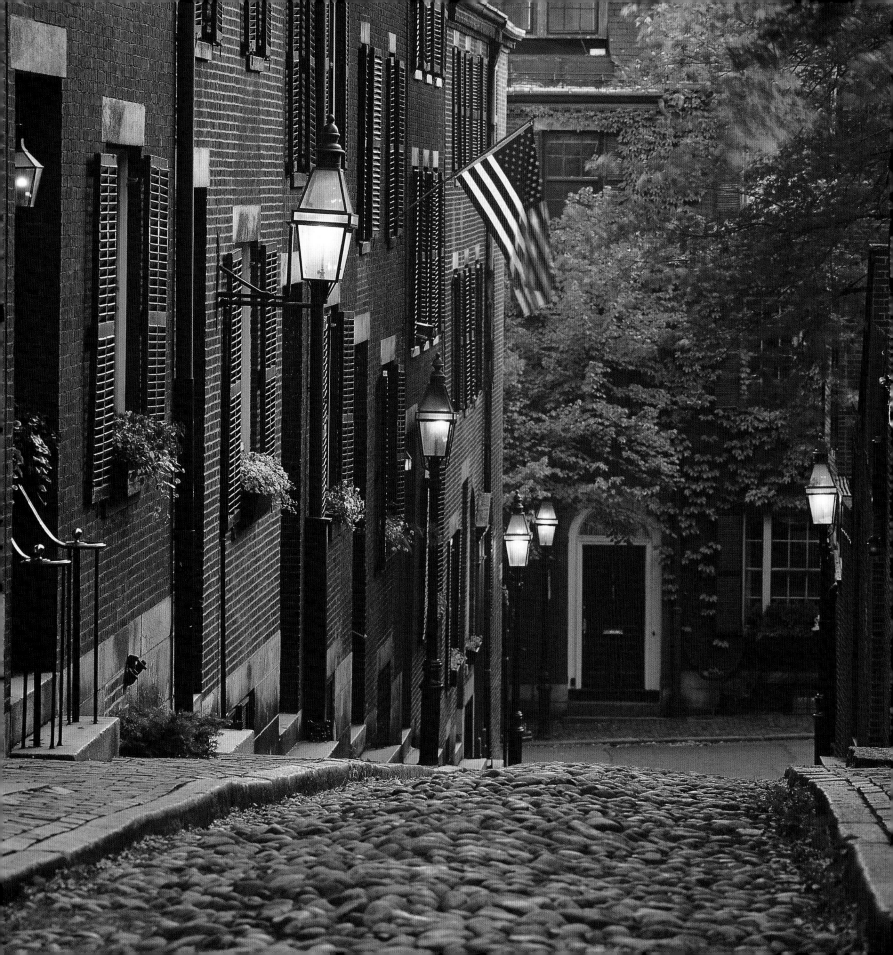

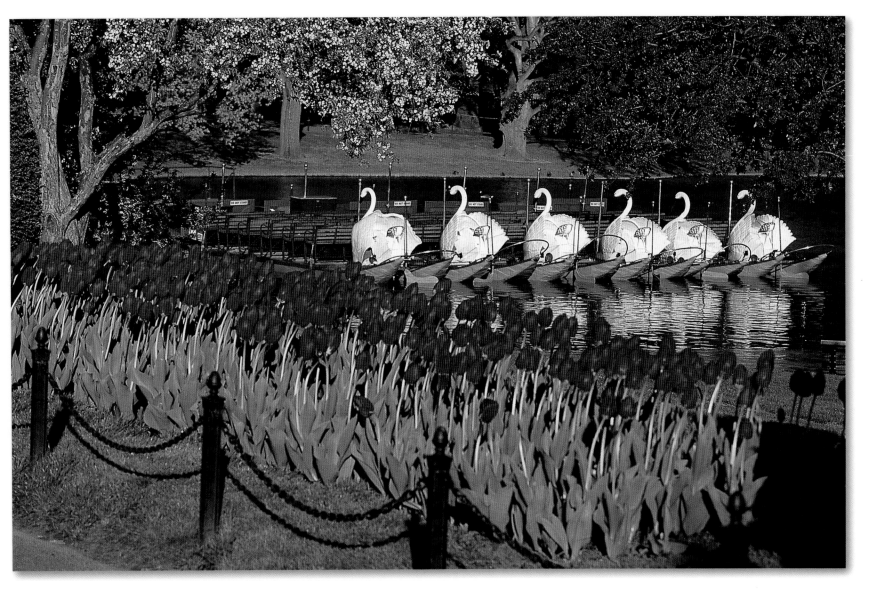

Boston's Public Garden boasts the first botanical garden in the nation, created in 1859. Visitors can admire blooms from around the world or tour the lagoon on a pedal-powered swan boat, a favorite city activity since 1877.

When the city of Boston planned to modernize the streets of Beacon Hill in the 1940s, local women staged a sit-in, successfully demanding that the historic brick sidewalks and cobblestone streets be preserved.

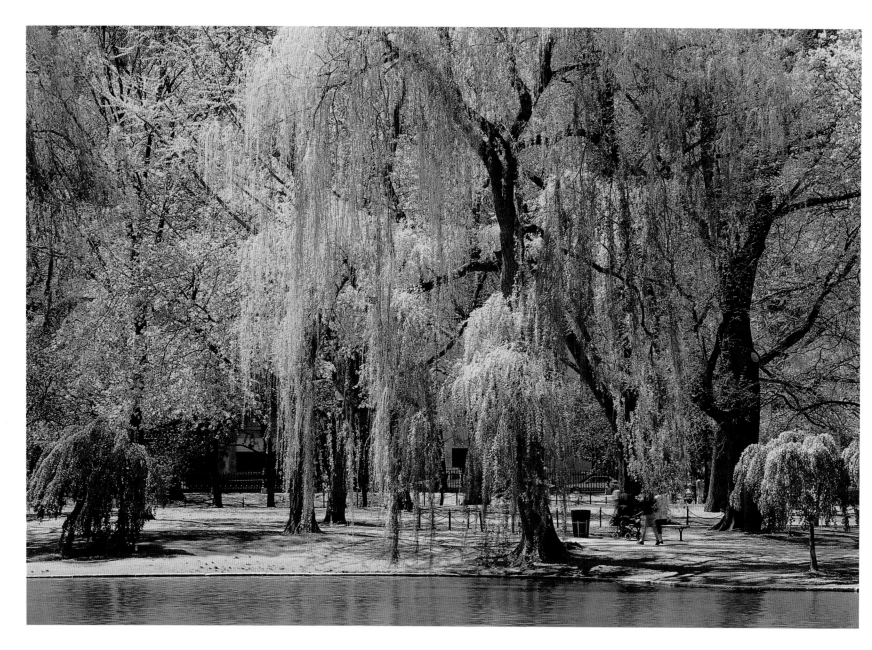

Wrought-iron gates, curving walkways, and park benches under
sweeping branches make the Public Garden a splendid place
for an afternoon of respite from the city.

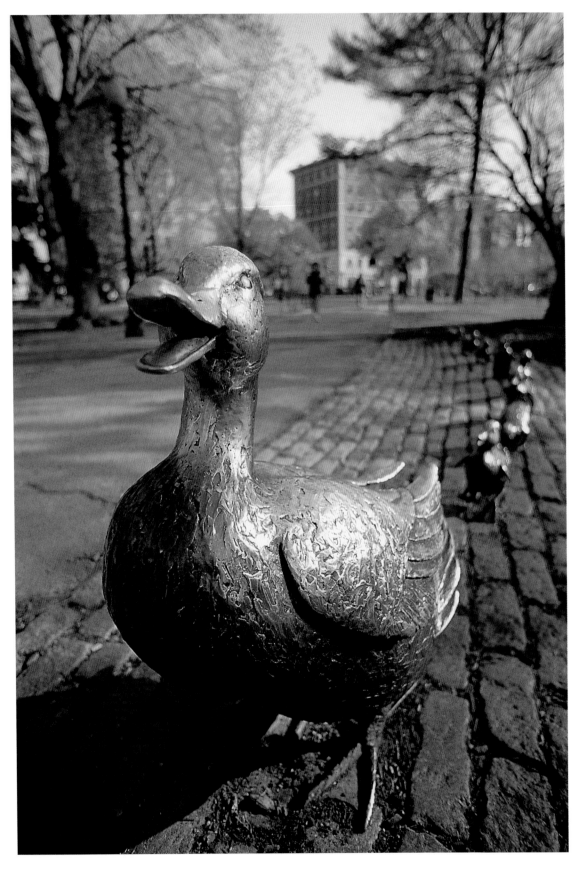

This whimsical sculpture within the Public Garden was inspired by *Make Way for Ducklings*, a children's book written by Robert McCloskey in 1941. For more than 20 years, Bostonians have flocked to a Ducklings Day Parade each May, following Mr. and Mrs. Mallard's fictional route through Beacon Hill.

*Parthenocissus tricuspidata*, the perennial vine growing over this brick building, is such a familiar sight in Boston that it is commonly known as Boston ivy. It is also known as grape ivy or Japanese creeper and is native to Asia.

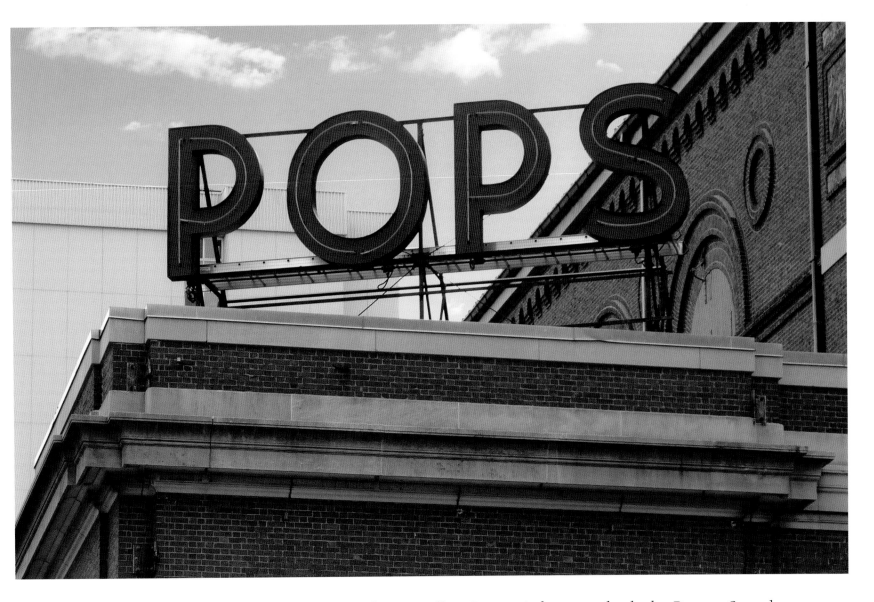

Symphony Hall in Boston is home to both the Boston Symphony Orchestra and the Boston Pops Orchestra. Completed in 1900, the hall accommodates both orchestras: it features rows of chairs for performances by the BSO, rows which are removed and replaced with more casual table and chair seating for Pops shows. The Boston Pops is renowned for playing more popular classical music and show tunes—traditionally lighter music than the orchestra.

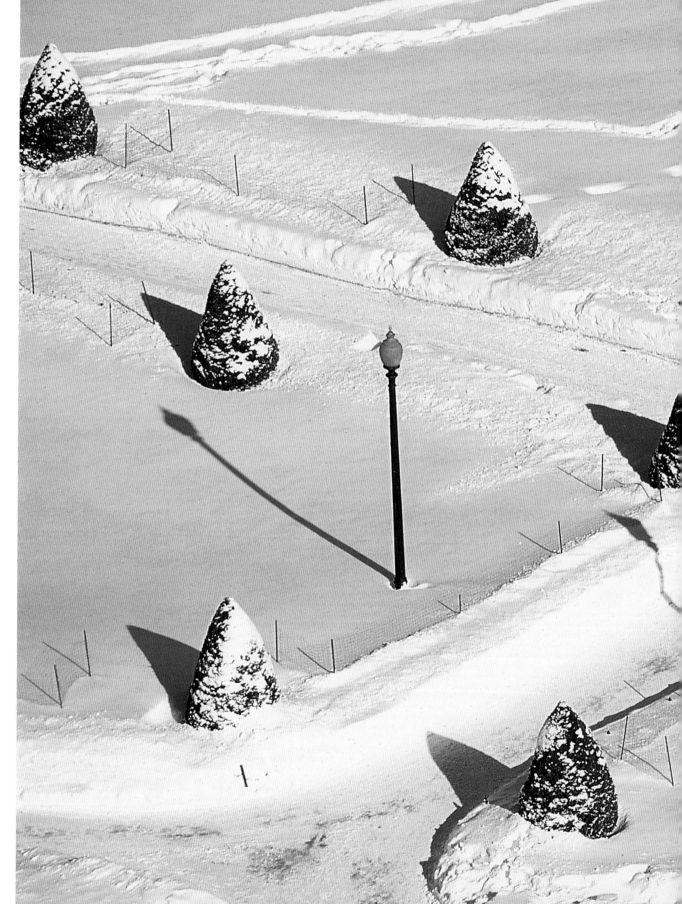

Fresh snow creates a winter wonderland in the Public Garden. This is just one of 215 parks maintained by the city. Together, the preserves total 2,200 acres, including public squares, green spaces, golf courses, and historic burial sites.

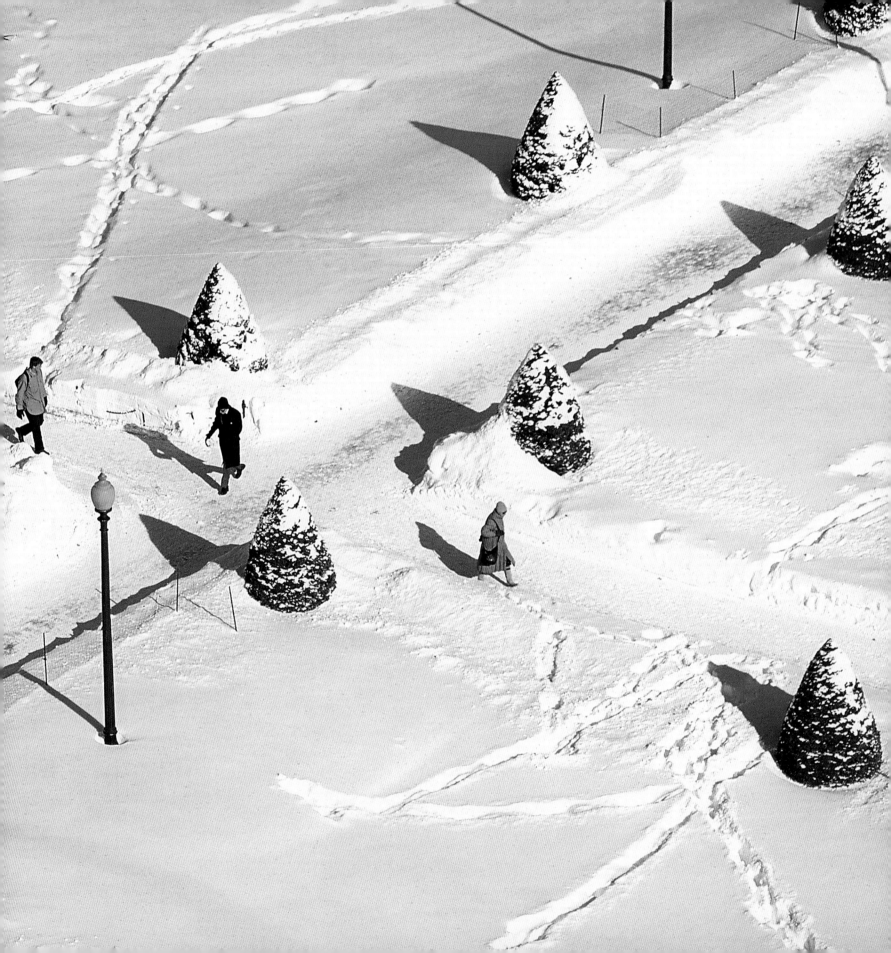

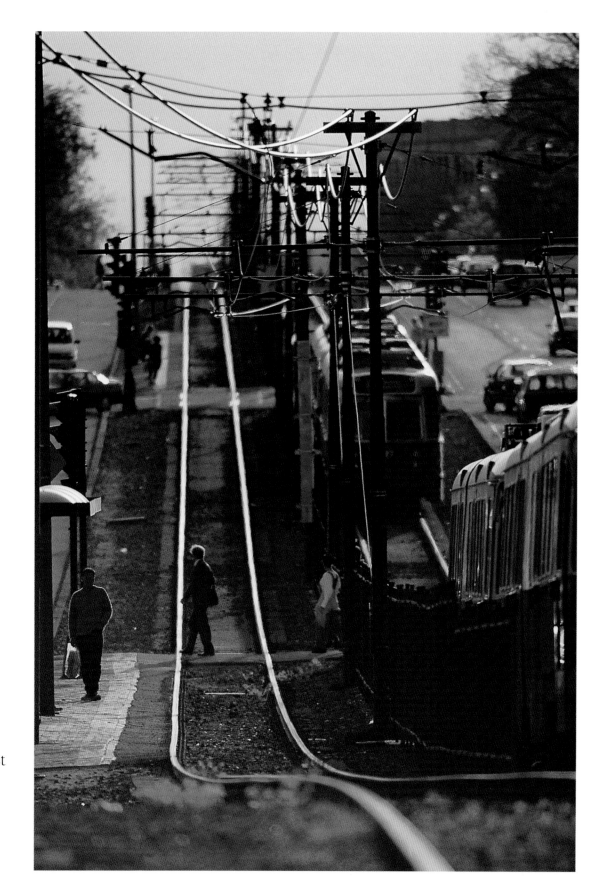

Rail lines along Beacon Street reflect dawn rays, greeting early morning commuters. The Massachusetts Bay Transportation Authority, or the "T," is one of America's oldest and largest public transportation systems.

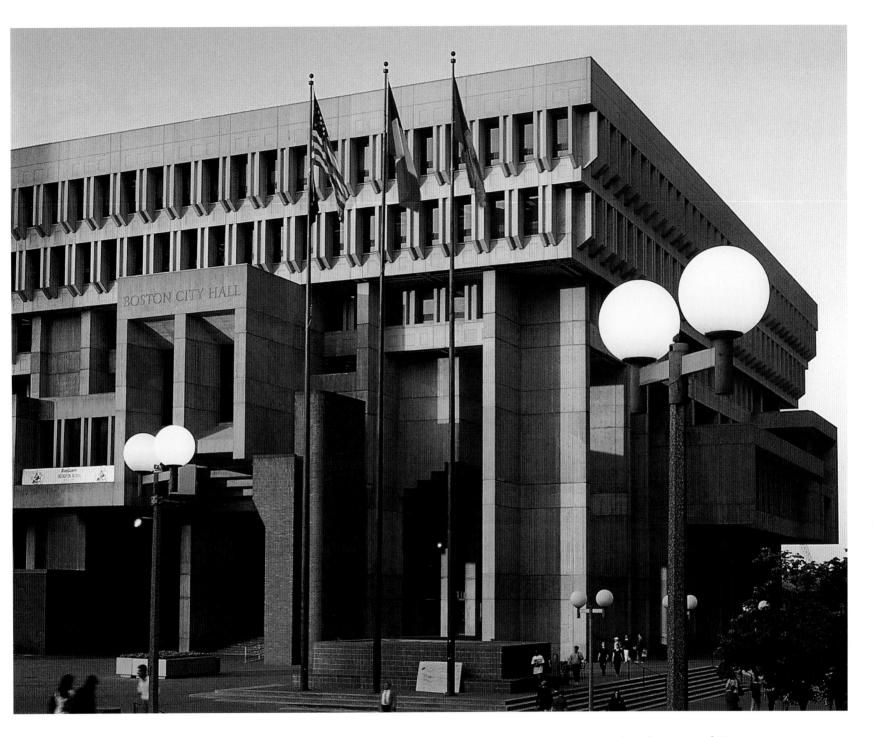

In contrast to the traditional domes and columns of Boston's State House and Old City Hall, the new city hall is stark and contemporary, created with massive concrete blocks. Its brick plaza draws people to outdoor performances each summer.

The six glass towers of the Holocaust Memorial represent the six death camps of World War II. A million prisoners' numbers etched onto each tower remind visitors of the war's horror.

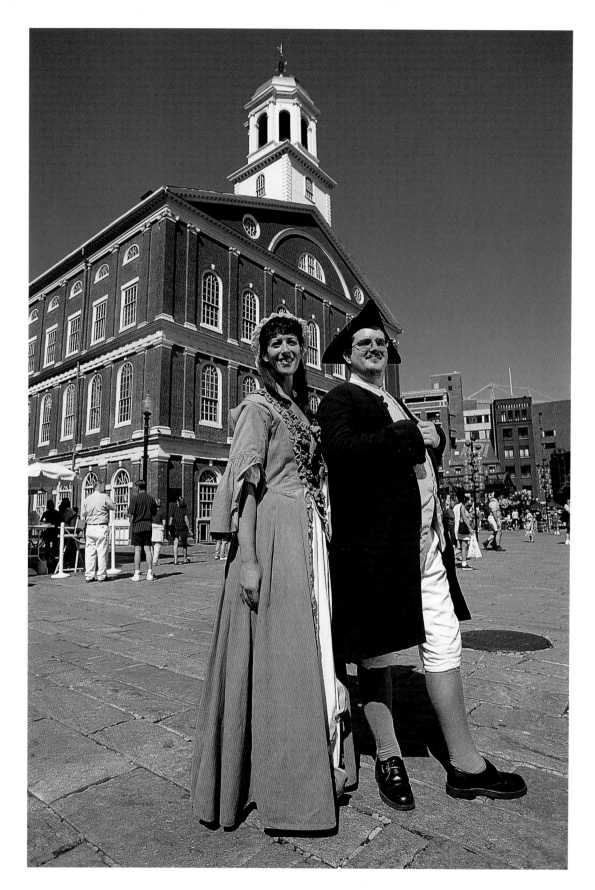

Actors along the Freedom Trail—a route past many of Boston's historic sites—portray characters from the city's past. William Dawes, like Paul Revere, set off in 1775 to warn of a British attack. Abigail Adams was a writer and an abolitionist as well as the wife of President John Adams.

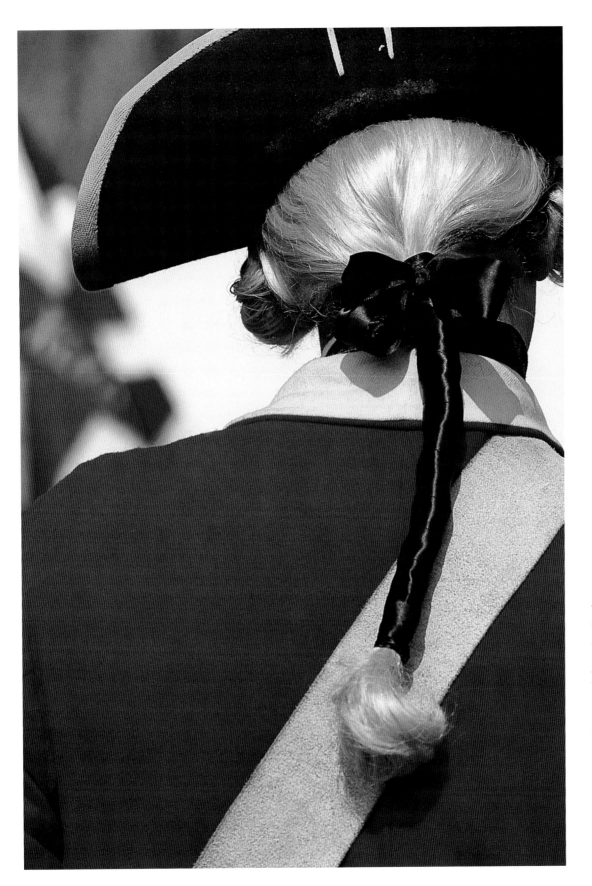

American militia men challenge British soldiers in a re-enactment of the American Revolution. Whisking spectators back to the battles of the past, players are meticulously dressed in authentic period clothing and outfitted with the weapons of the time.

Samuel Adams once held a crowd enthralled in the upstairs meeting room of Faneuil Hall. His message—independence from Britain. The hall has seen more than two centuries of history since then, and it remains one of Boston's most striking sights.

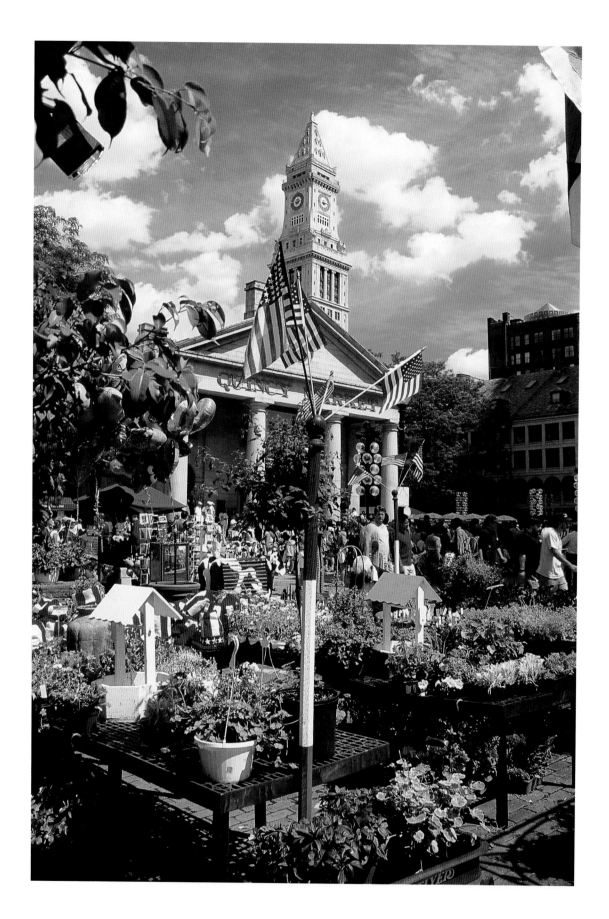

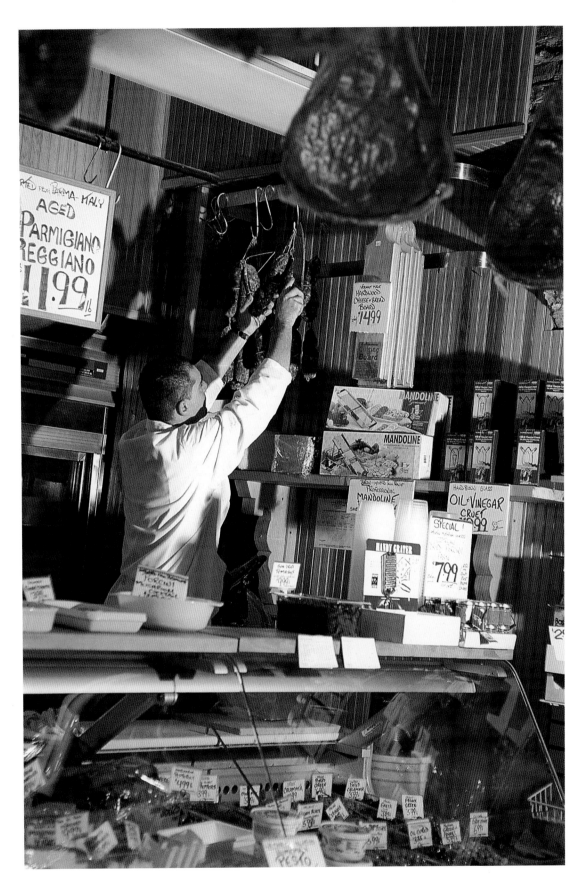

Italian delis and bakeries, produce markets, and cafés line the streets of Boston's North End. Each weekend throughout the summer, residents take to the streets in celebration of a different Italian feast day.

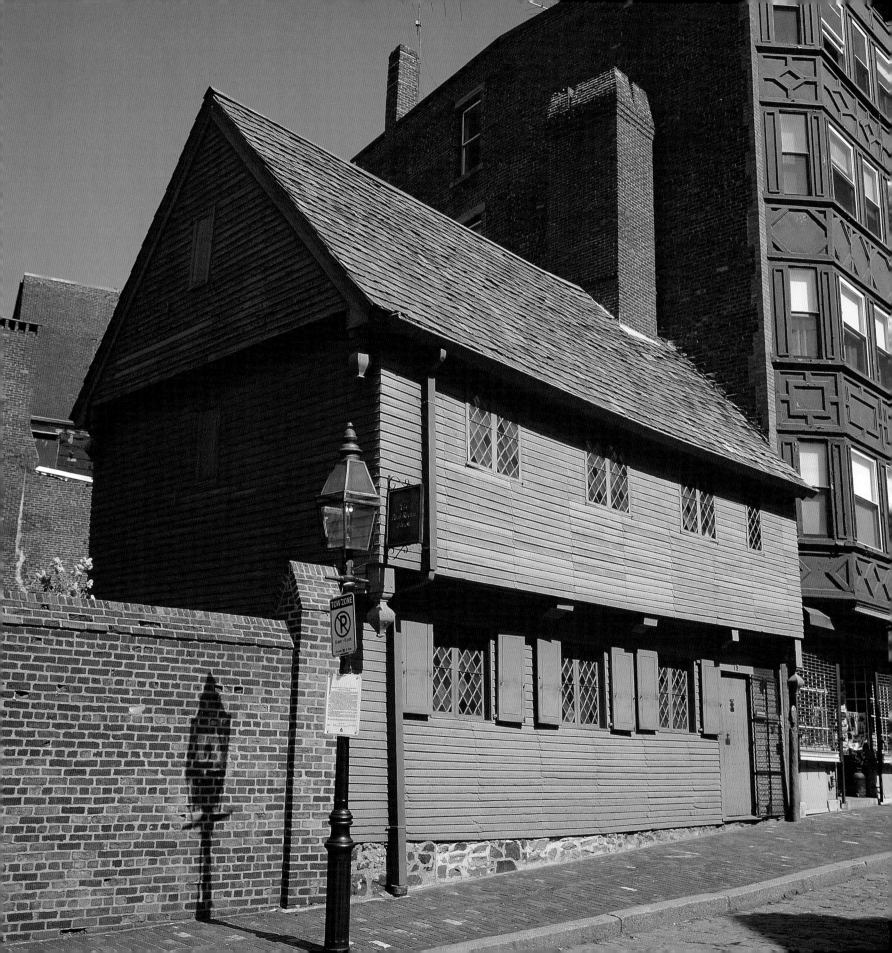

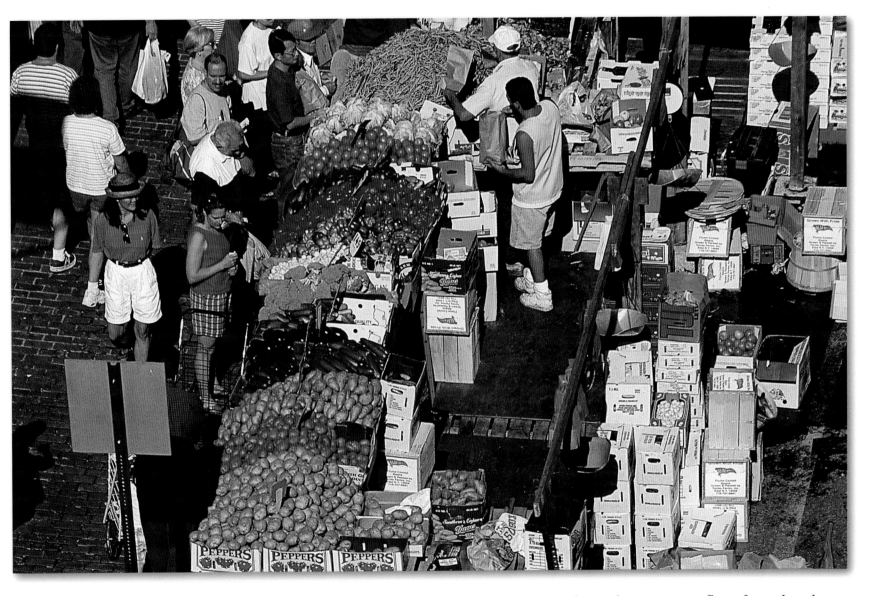

Sugar cane, seafood, produce, and much more overflow from kiosks as vendors shout and beckon to passersby. Chaos is all part of the appeal of the Haymarket in the North End.

When Paul Revere bought this merchant's home on North Square, it was already a century old. Today the circa 1680 building is a museum dedicated to preserving the story of Paul Revere's life and his midnight ride.

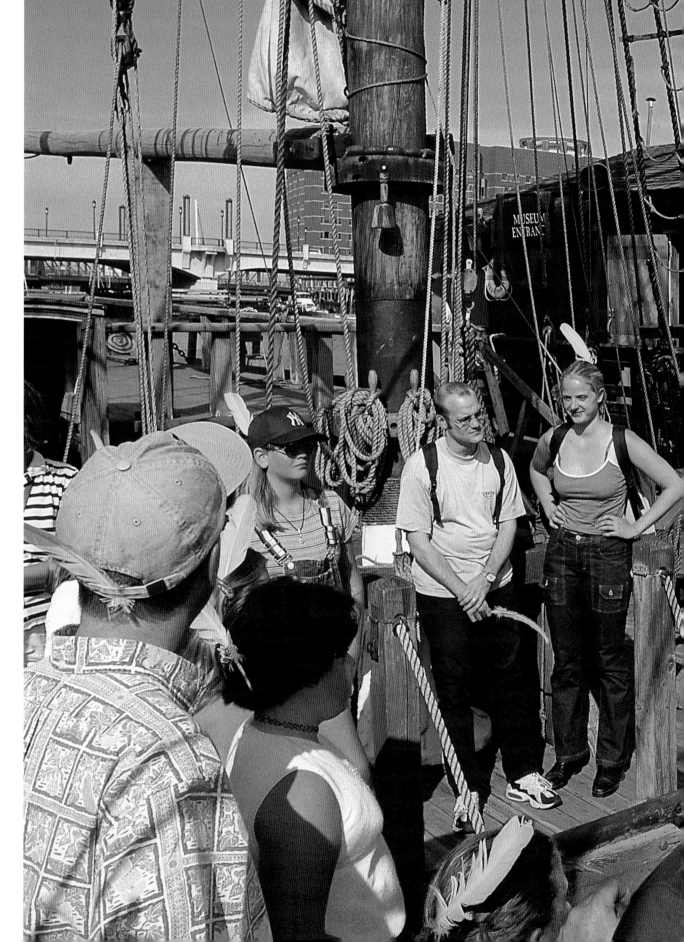

A storyteller brings the Boston Tea Party to life for visitors. In 1773, citizens were unhappy about paying high British taxes without representation in the British government. When the British refused to repeal the tax on tea, a group of men disguised themselves as natives, boarded three ships, and dumped their cargoes into the harbor.

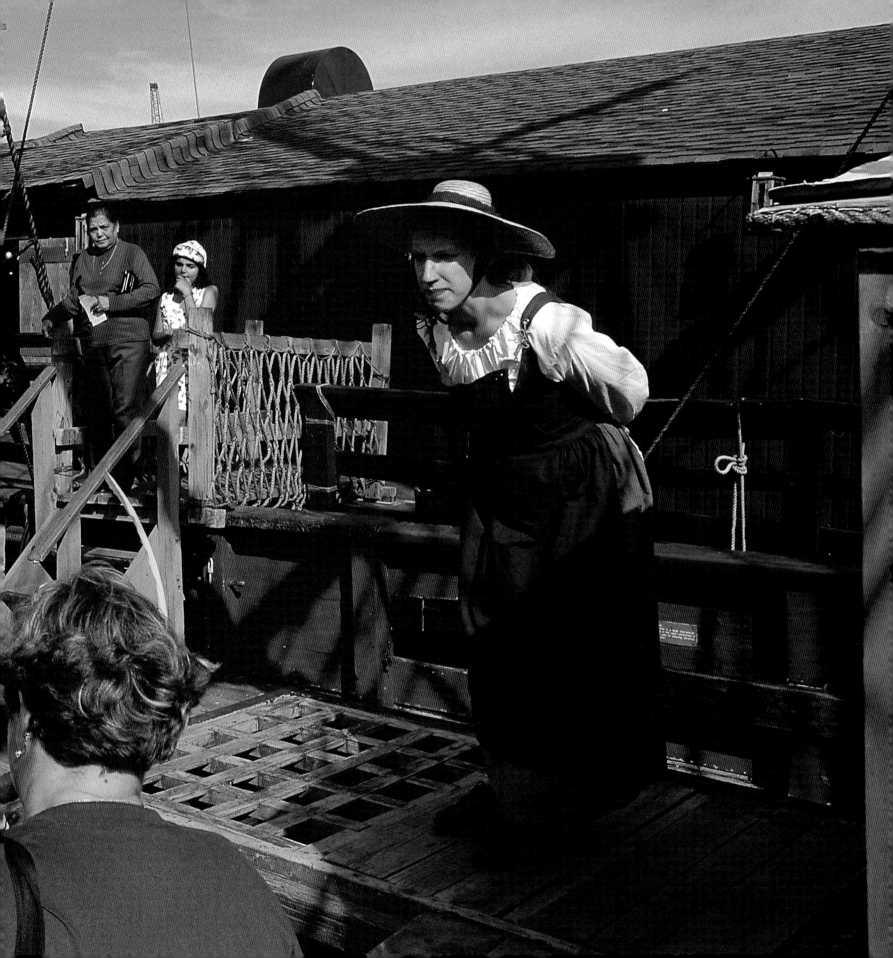

A mob gathered outside the Customs House in 1770, taunting the British soldiers posted there. When the mob grew near enough to use their clubs, the soldiers fired, killing five and wounding six others. The Boston Massacre, as the event came to be called, incited revolutionary troops in the approaching war.

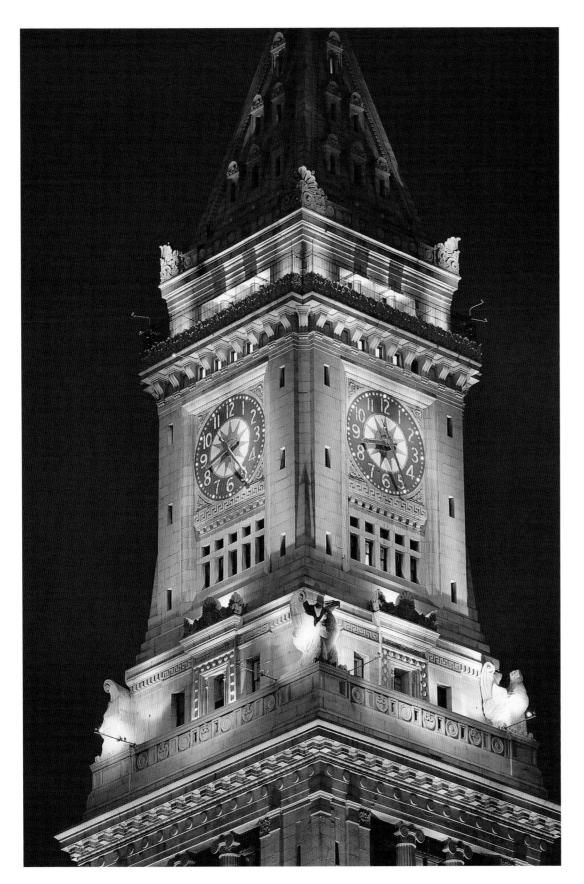

When it was built in 1915, the Customs House tower was one of the tallest in the nation, looming 496 feet above the historic downtown district.

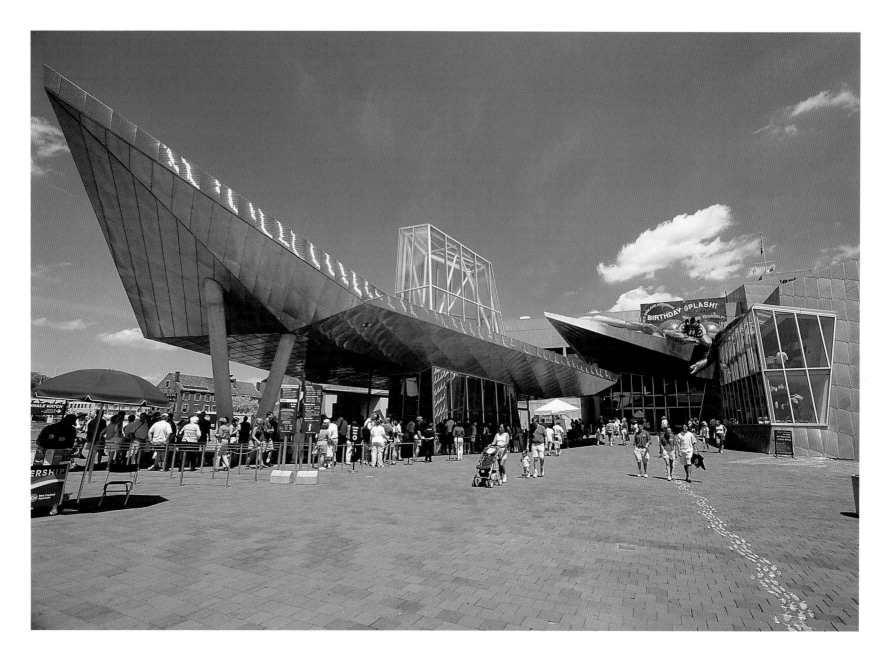

Inside the New England Aquarium, sightseers discover a four-storey tank displaying the diversity of a coral reef as well as colorful fish and sea turtles. More than 8,000 other creatures inhabit the aquarium, from crocodiles to sharks.

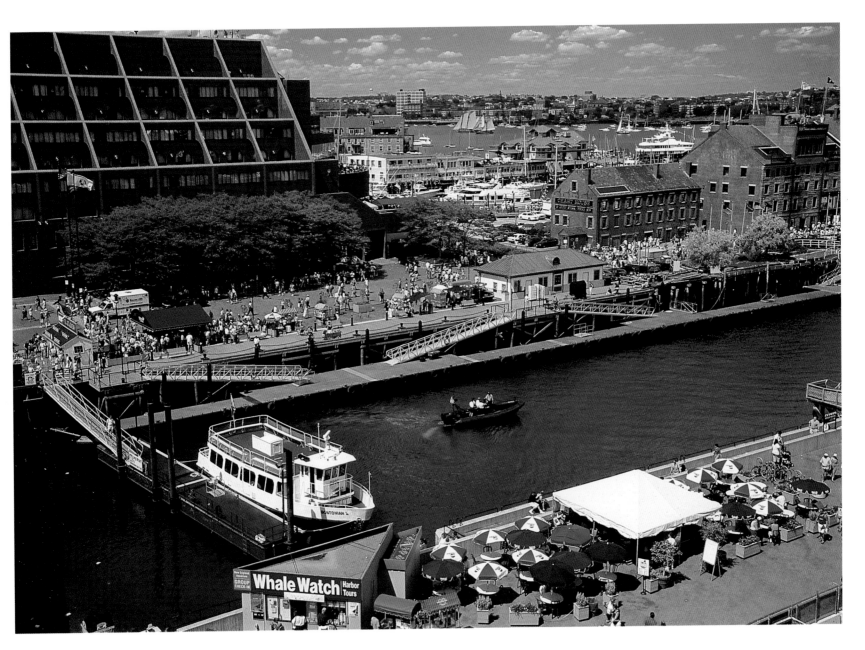

Boston's harbor was a meeting place for native people for thousands of years before the Pilgrims reached New England shores. Fishing traps unearthed near here date to the time when the first Egyptian pyramids were built.

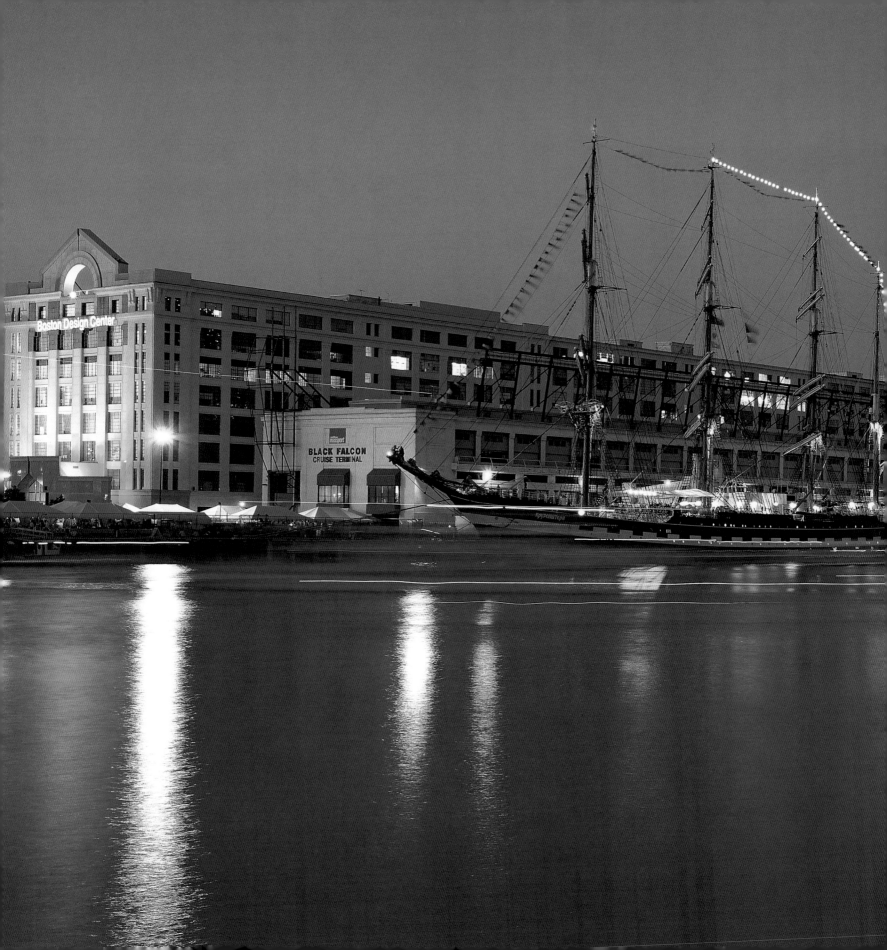

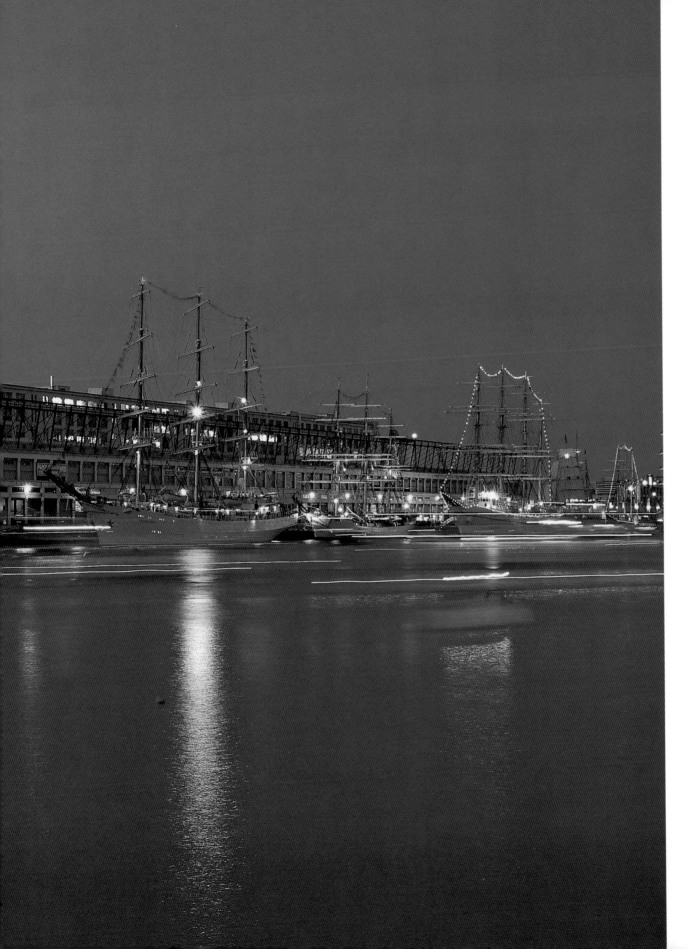

Tall ships line the pier, awaiting a morning celebration of Boston's shipping history. The city harbor hosts an ever-changing line-up of summer entertainment and events, from outdoor concerts and afternoon cruises to fireworks.

The world's oldest commissioned warship that is still afloat, the USS *Constitution* is on display at the Charlestown Navy Yard. Old Ironsides, as the ship is dubbed, sailed to battle in the war with Tripoli and in the War of 1812.

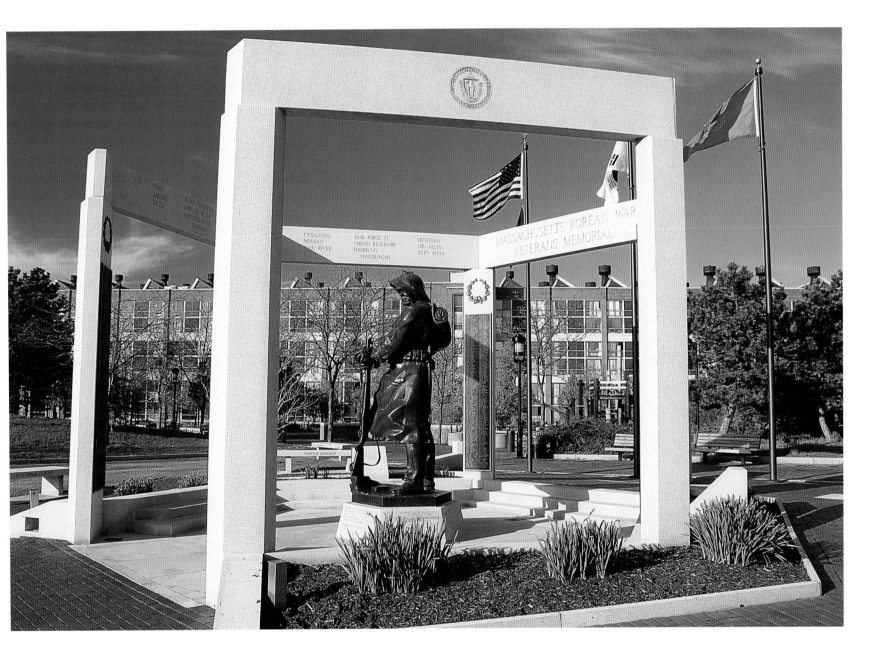

This memorial to the Korean War stands in the Charlestown Navy Yard, part of Boston National Historic Park. From 1800 to 1974, the navy yard produced and maintained more than 200 warships.

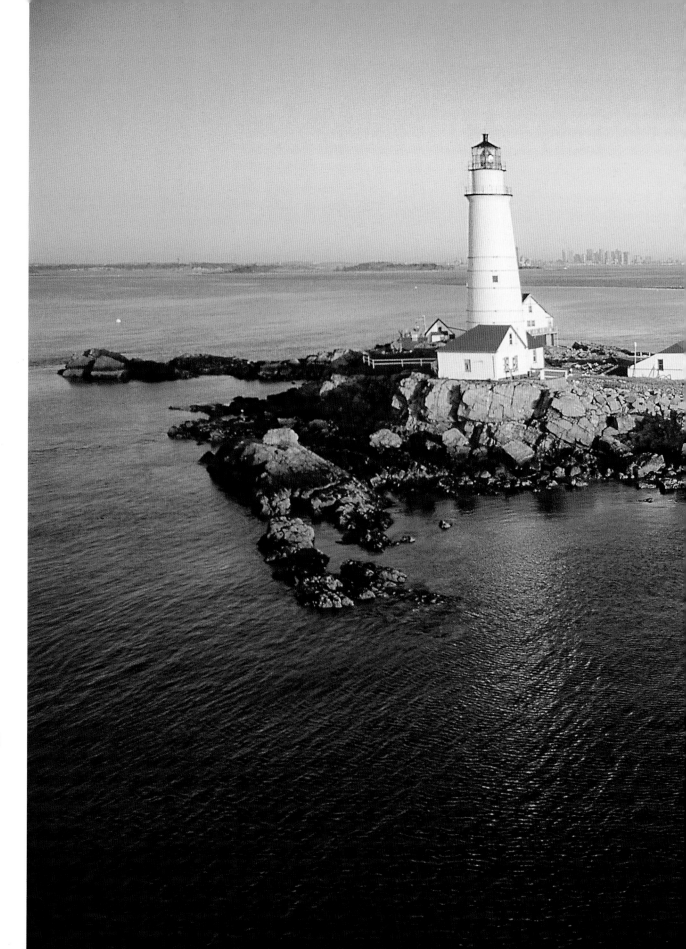

A beacon has shone from Little Brewster Island in Boston Harbor since North America's first lighthouse was built here in 1716. The original tower was destroyed in the Revolutionary War and rebuilt in 1783.

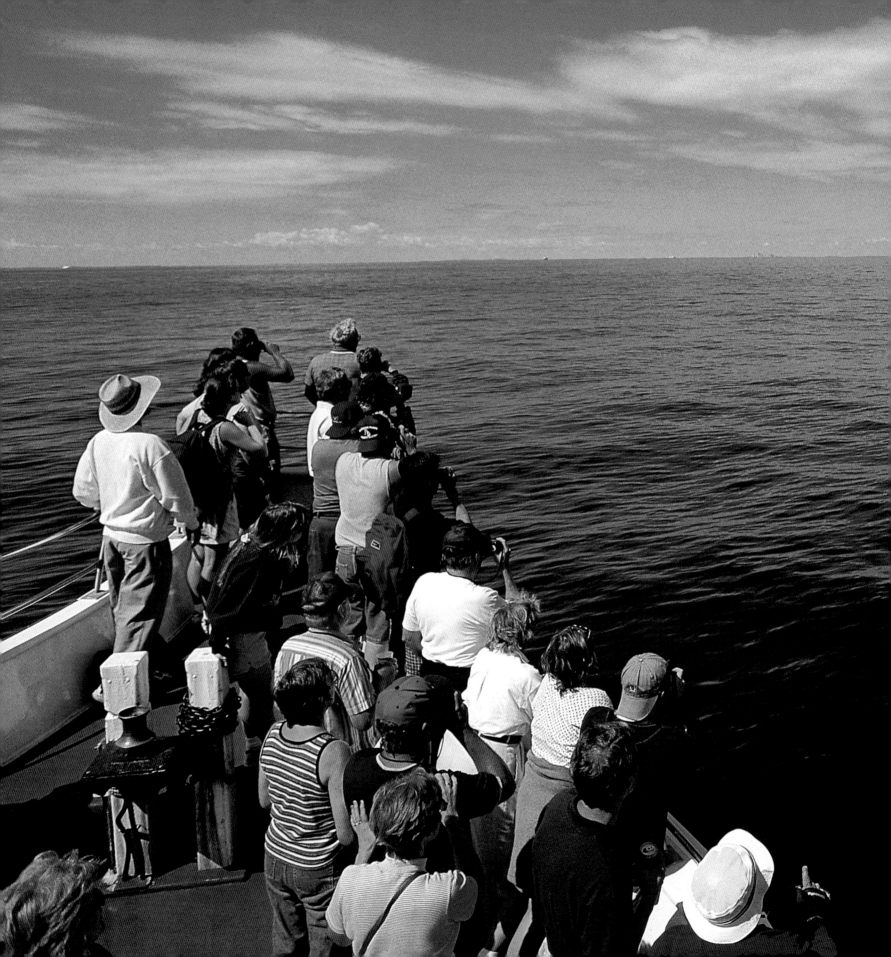

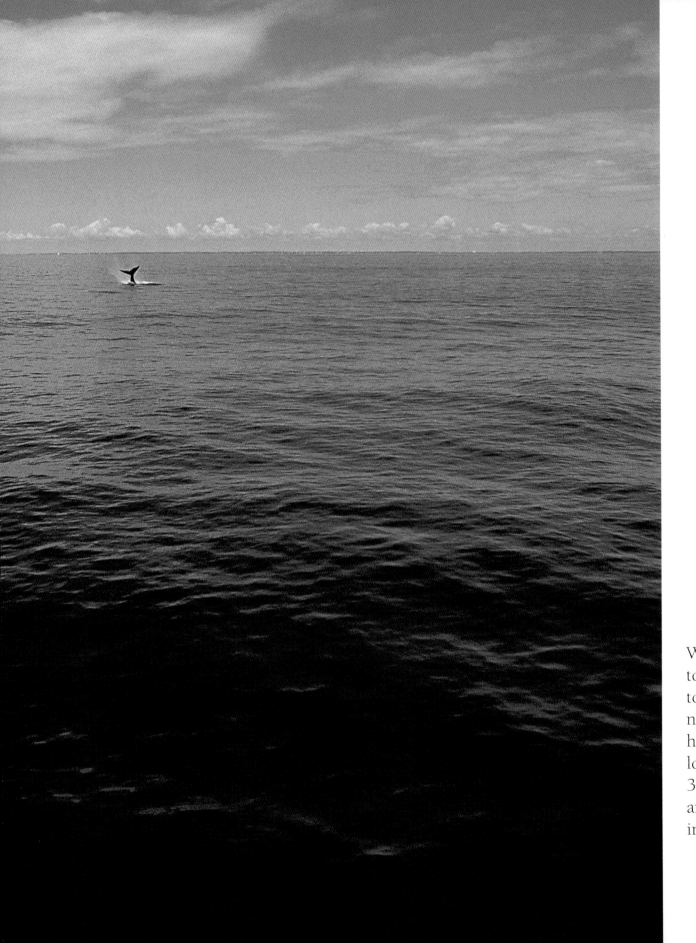

Whale-watching tours allow sightseers to view threatened northern hemisphere humpbacks, 50 feet long and weighing 37 tons. Fin whales and minkes also inhabit these waters.

A giant milk bottle greets kids with ice cream and snacks as they exit the Boston Children's Museum. A pioneer in interactive exhibits, the museum features a climbing wall, a science playground, replicas of some of Boston's vessels and waterways, and more.

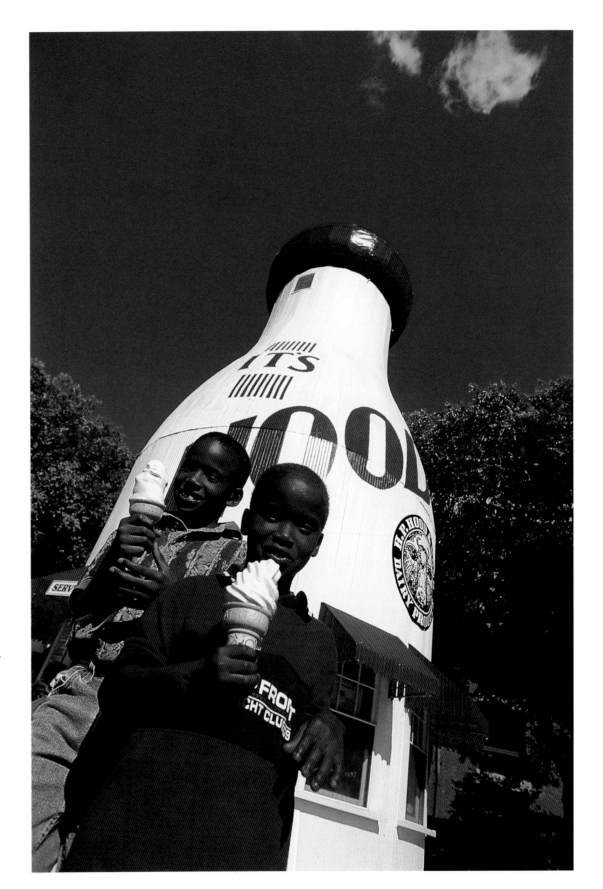

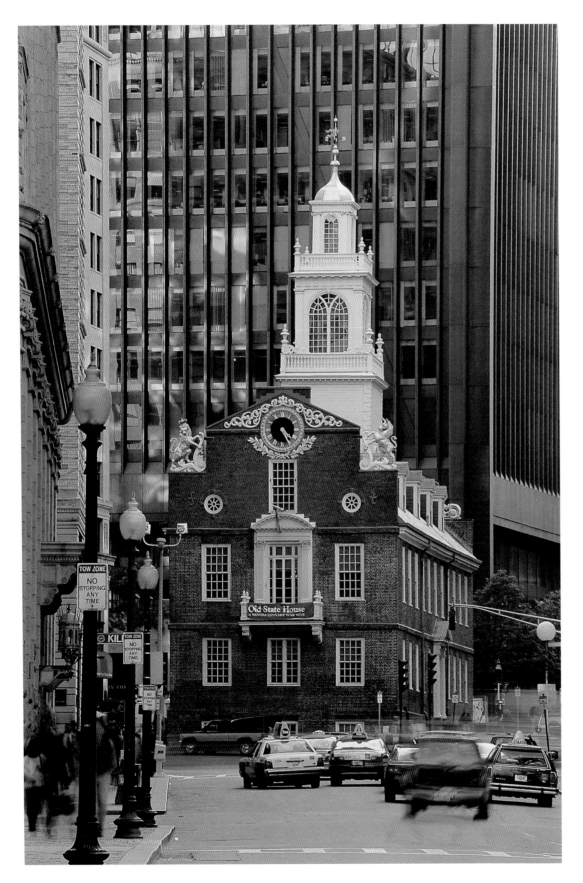

Boston's oldest public building, the Old State House, was built in 1713. Sixty-three years later, citizens gathered in the street below to hear the Declaration of Independence read for the first time in Massachusetts. The event is re-enacted here each July 4.

Artists' lofts, galleries, and hip eateries line the streets of the historic Leather District. The neighborhood earned its name in the 1870s when about 500 leather wholesalers and dealers offered their wares to the city's shoemakers.

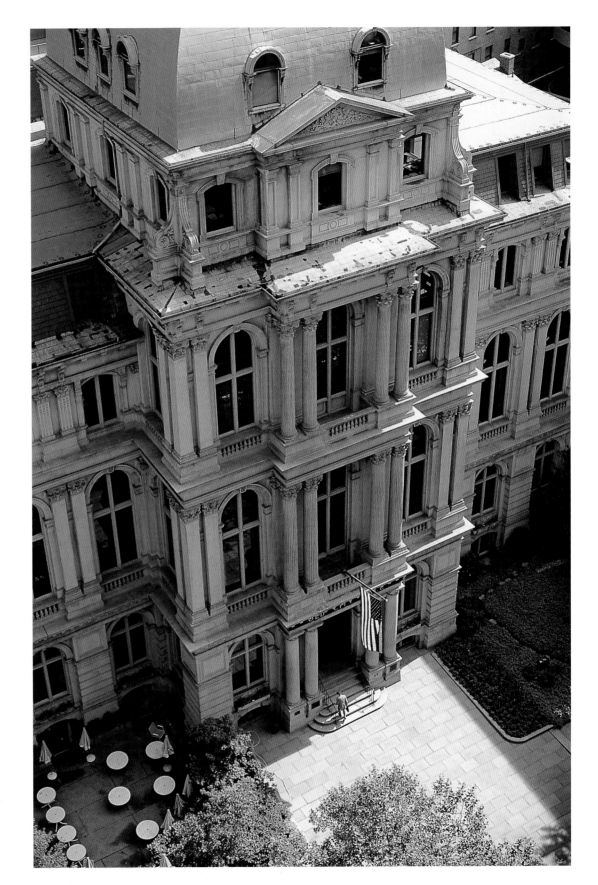

Boston's center of government from 1865 to 1969, the Old City Hall has been converted into office and retail space. The renovations caught the attention of architects across the continent—this was one of the first public buildings to be used for new purposes.

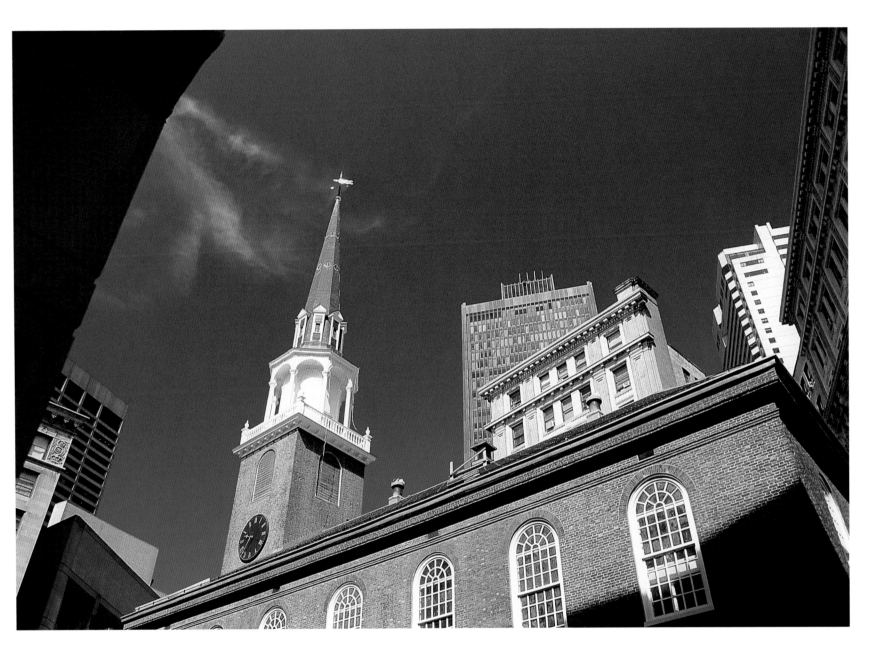

Built in 1729, the Old South Meeting House was primarily a church, but it was also the site of many public events. One meeting here in 1773 led to the infamous Boston Tea Party. A citizens' movement led by Louisa May Alcott and Ralph Waldo Emerson helped save the building from destruction in the 1800s.

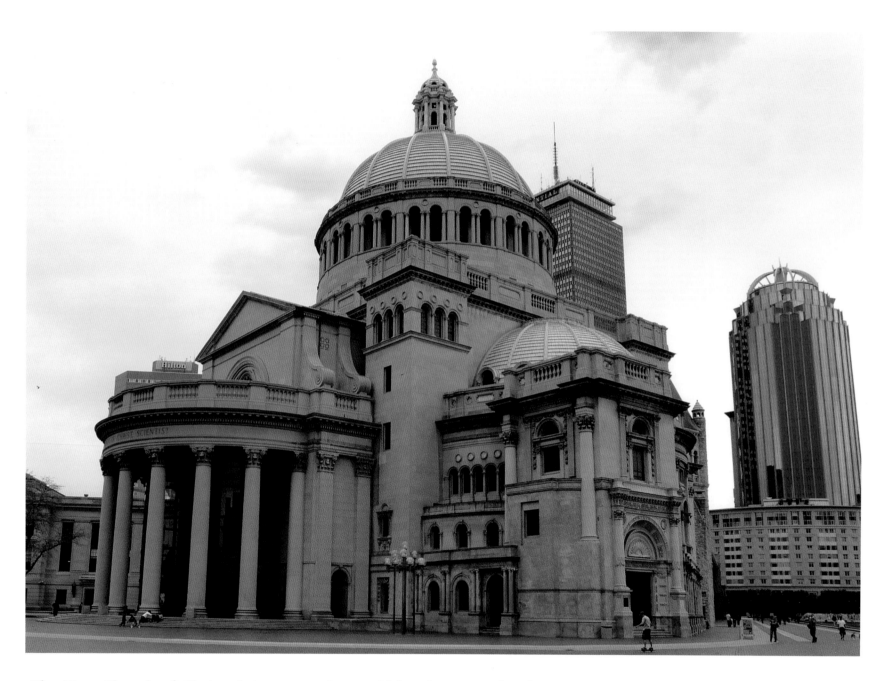

The First Church of Christ, Scientist, is the world headquarters for the
Christian Science faith, which was founded in the late 19th century by
Mary Baker Eddy. Built in 1894, this church is home to one of the largest
organs in the world—it has over 13,000 pipes.

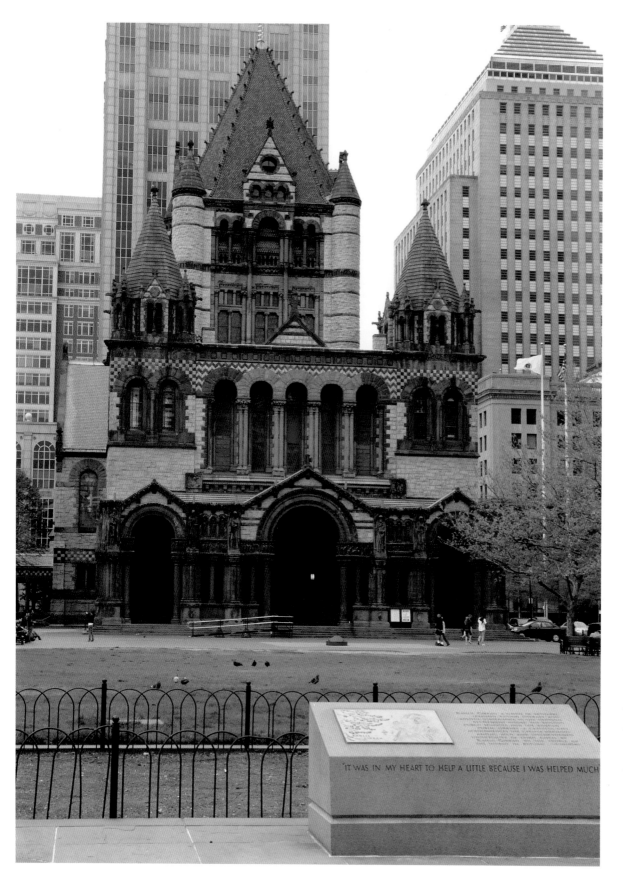

This memorial plaque in honor of poet Kahlil Gibran in Boston's Copley Square bears the phrase "It was in my heart to help a little because I was helped much." Gibran, who wrote *The Prophet*, immigrated to Boston from Lebanon with his family at the end of the 19th century.

Built for the John Hancock
Life Insurance Company—
in turn named for Massa-
chusetts' first governor—
the John Hancock Tower is
the highest and one of the
most recognizable structures
in the city. The 62-storey
building was designed by
famed architect I.M. Pei.

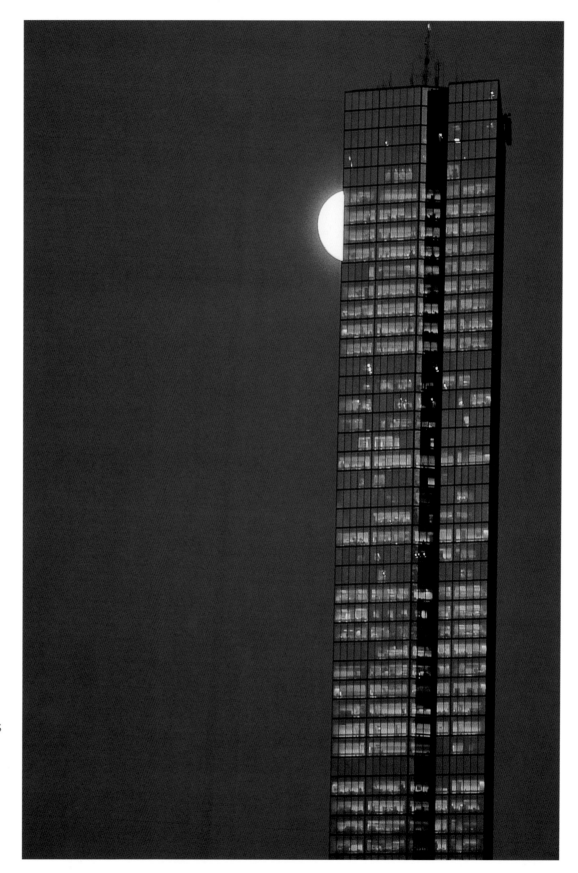

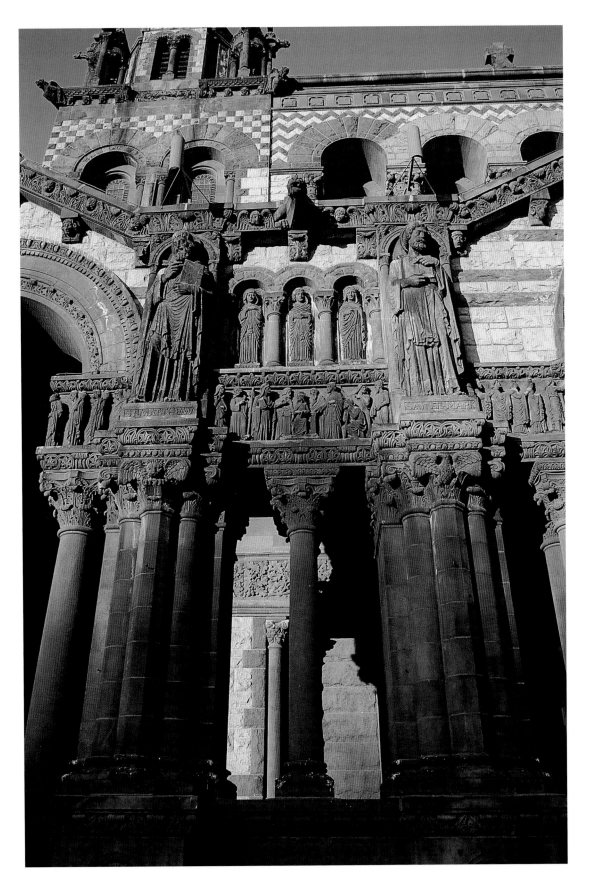

The American Institute of Architects calls Boston's Trinity Church one of the ten greatest public buildings in the United States. Built in 1877, the church features 103-foot-high ceilings, carved walnut support beams, intricate murals, and enormous columns.

One of Boston's liveliest spots, Copley Square is home to Trinity Church, the John Hancock Tower, and the Museum of Fine Arts. The square is packed one weekend a year as runners in the Boston Marathon cross the finish line.

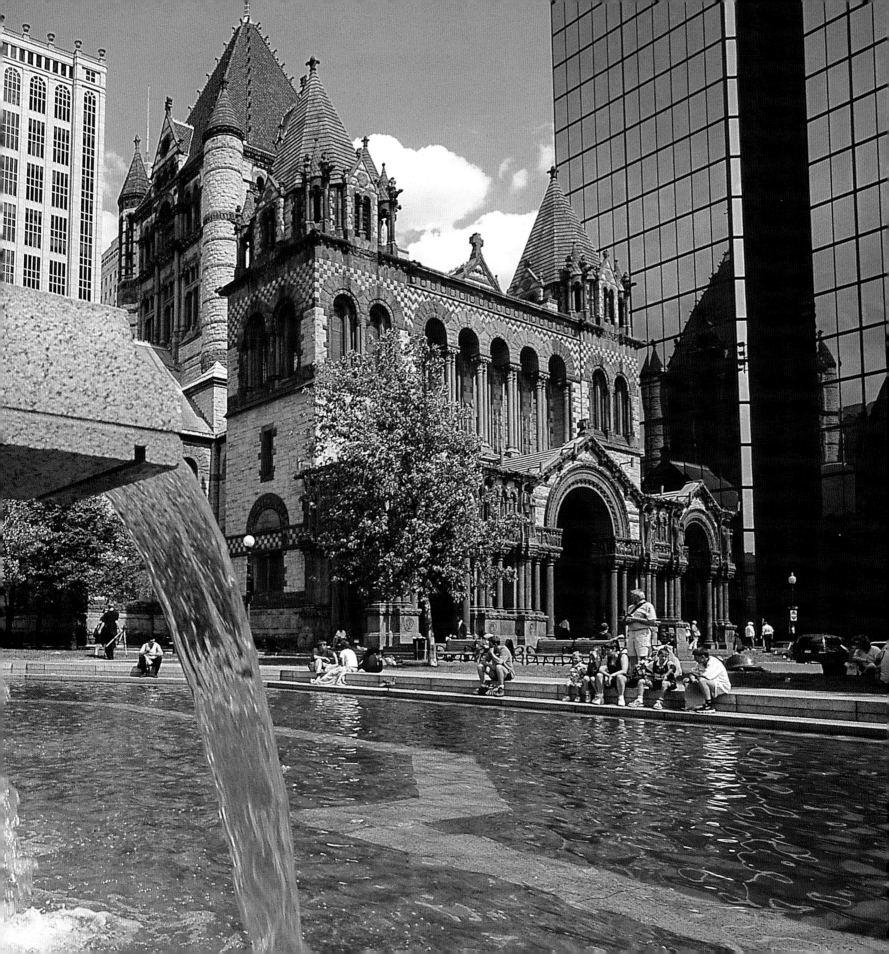

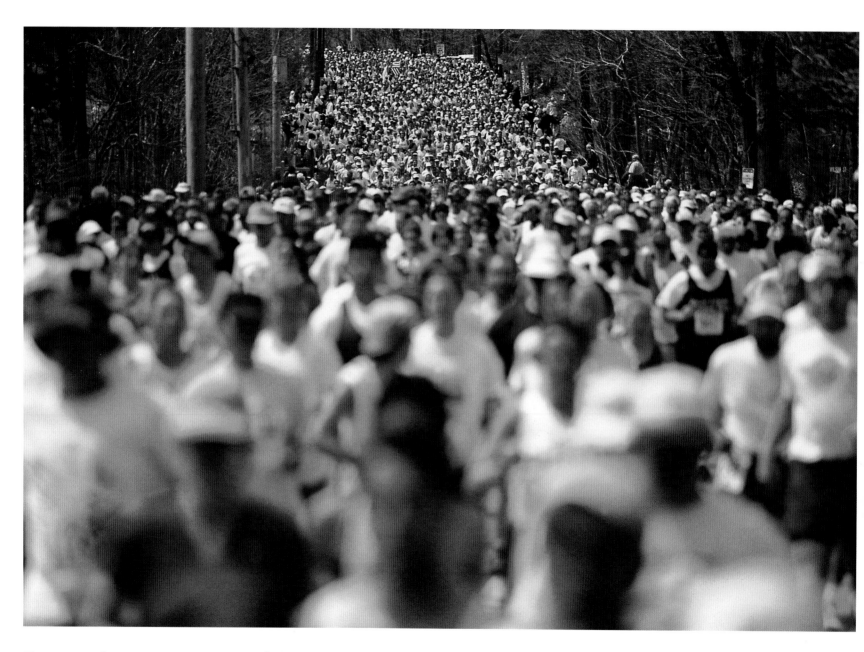

For more than a century, some of the world's best runners have gathered each spring for the Boston Marathon. The fastest of the athletes run the 26.2-mile route from Hopkinton to Copley Square in less than two and a half hours.

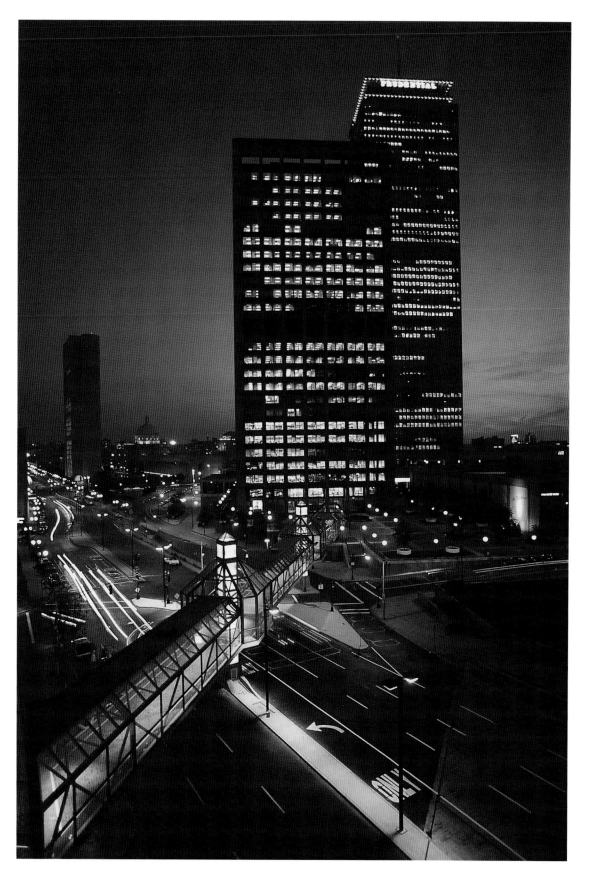

Completed in 1965, Prudential Center was the tallest building in Boston until the John Hancock Tower was built in 1976. From the observation deck on the Prudential Center's 50th floor, sightseers enjoy a 360-degree view of the city below.

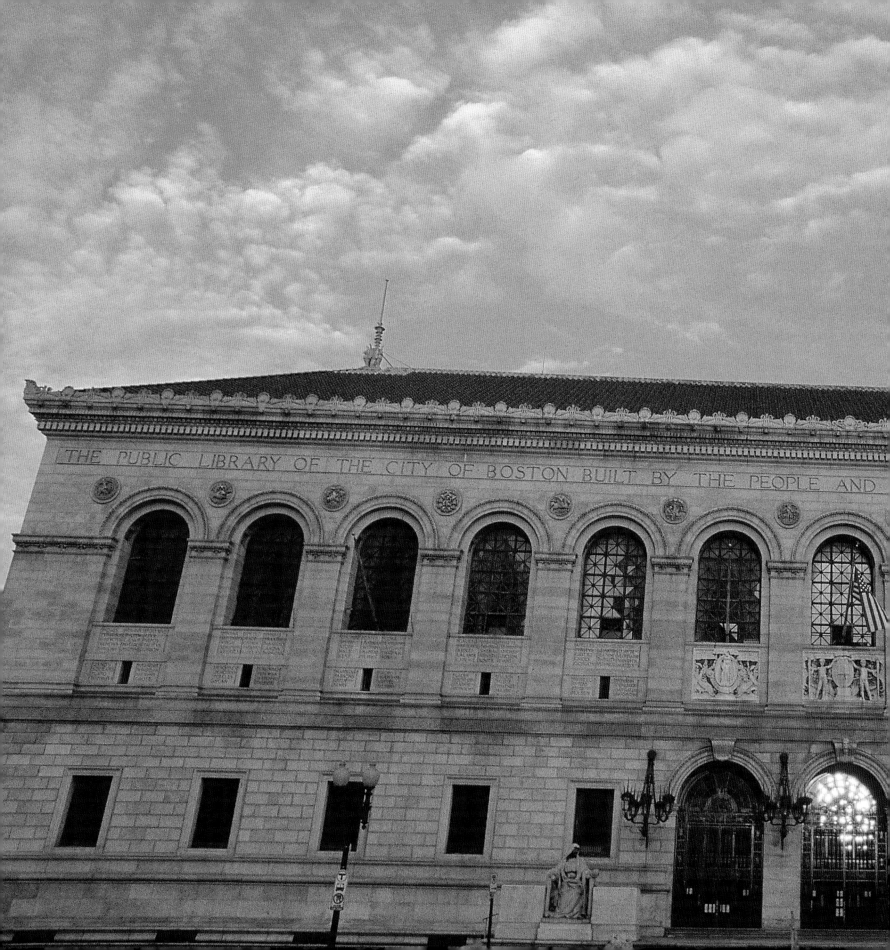

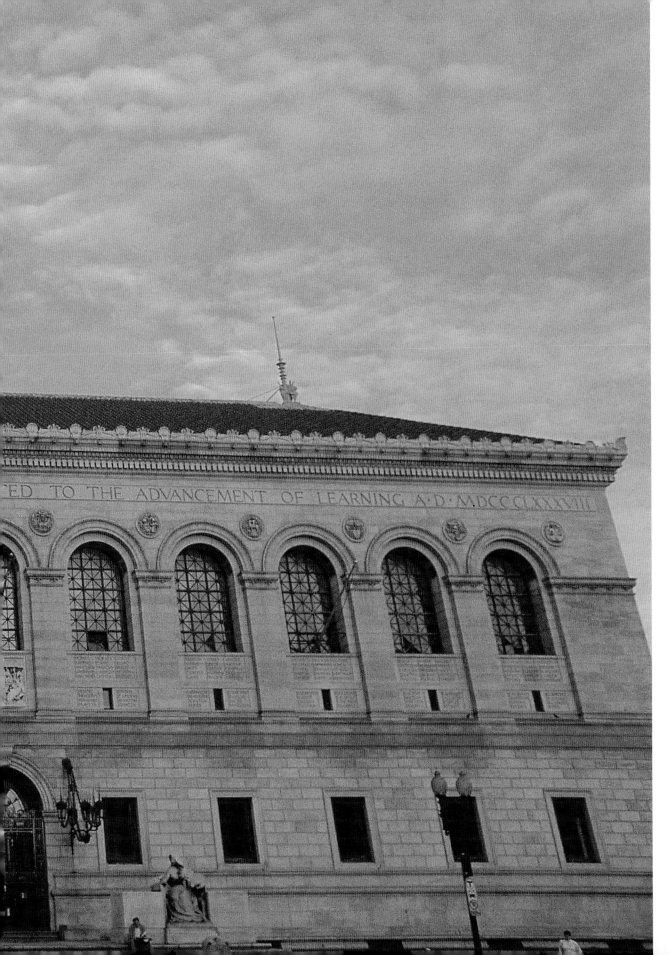

Looming above Copley Square, the Boston Public Library adds a touch of awe to the act of reading. Built in the late 1800s, the library includes a massive reading room, complete with marble floor and high arched windows.

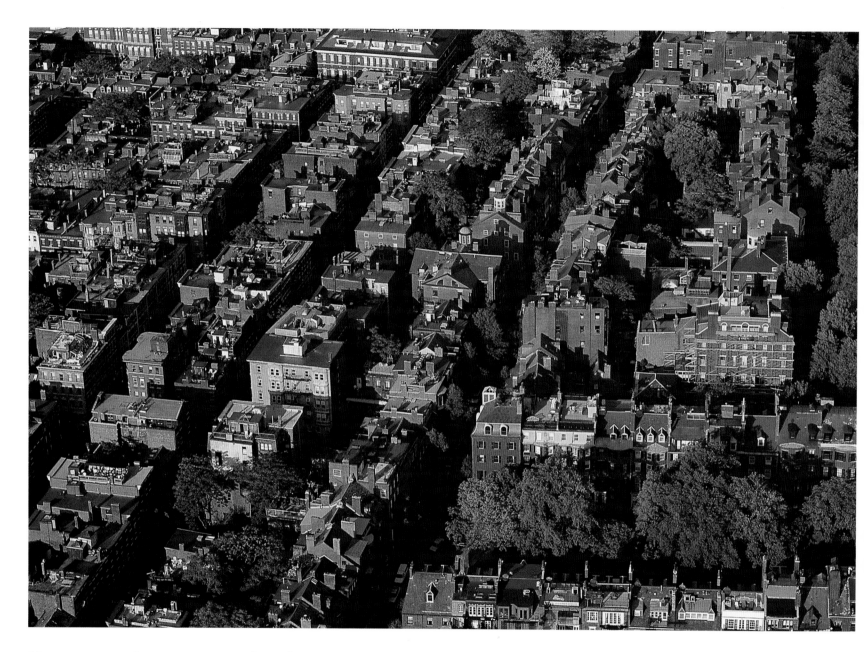

Visitors to Back Bay may wonder where the namesake bay is. In fact, the neighborhood is built directly over what was once a shallow backwater. The land was filled in the late 1800s, and today this is one of the city's most prestigious neighborhoods.

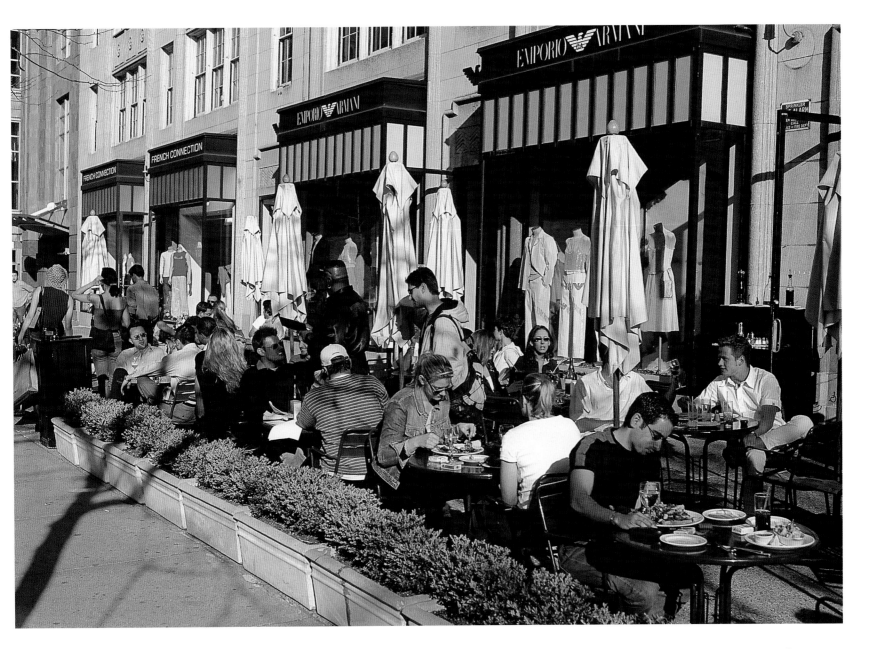

Taking a break from shopping, diners enjoy the sunshine at one of Newbury Street's outdoor cafés. The Back Bay neighborhood has more than 300 shops and restaurants, most housed in picturesque 19th-century townhomes.

This mural on Newbury Street features 81 famous Bostonians, from Ralph Waldo Emerson and John F. Kennedy to Babe Ruth and Bette Davis. Hunting for famous faces is a popular visitor pastime.

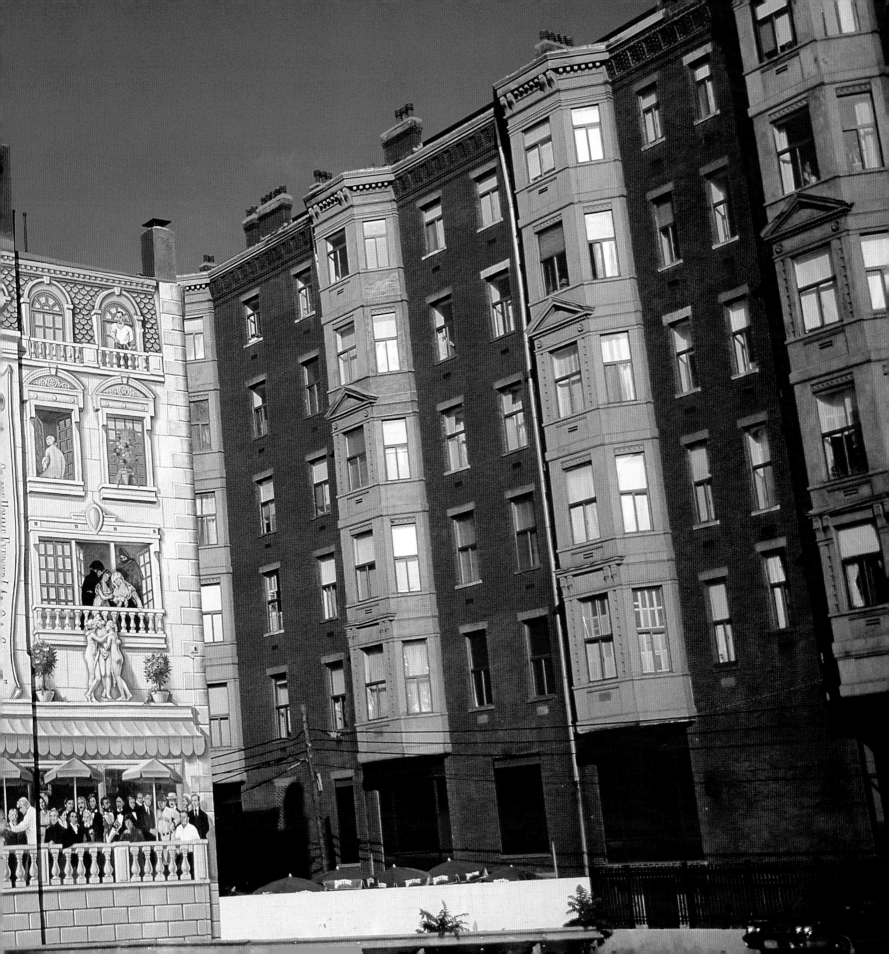

One of America's best known antiquarian booksellers, the Brattle Book Shop was founded in 1825. More than 250,000 books, maps, and prints fill the shelves from the floorboards to the rafters.

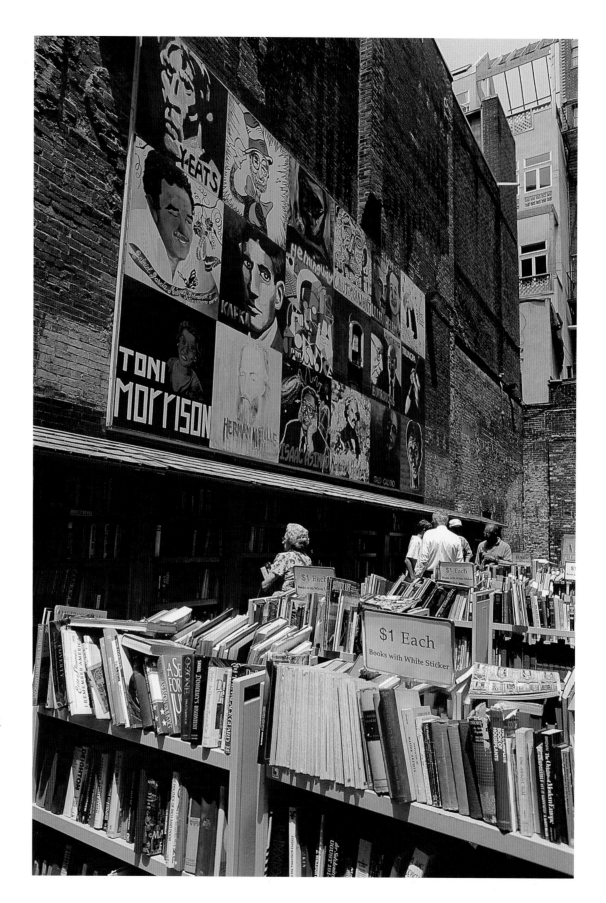

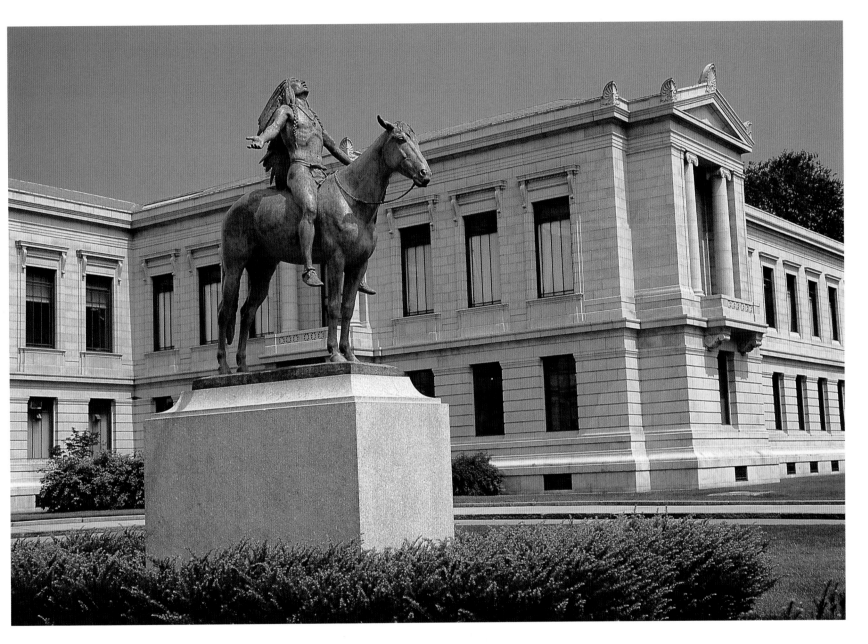

From artifacts of ancient Egypt to 20th-century abstract paintings, the Museum of Fine Arts is a celebration of human creativity. Thousands of students tour these galleries every year.

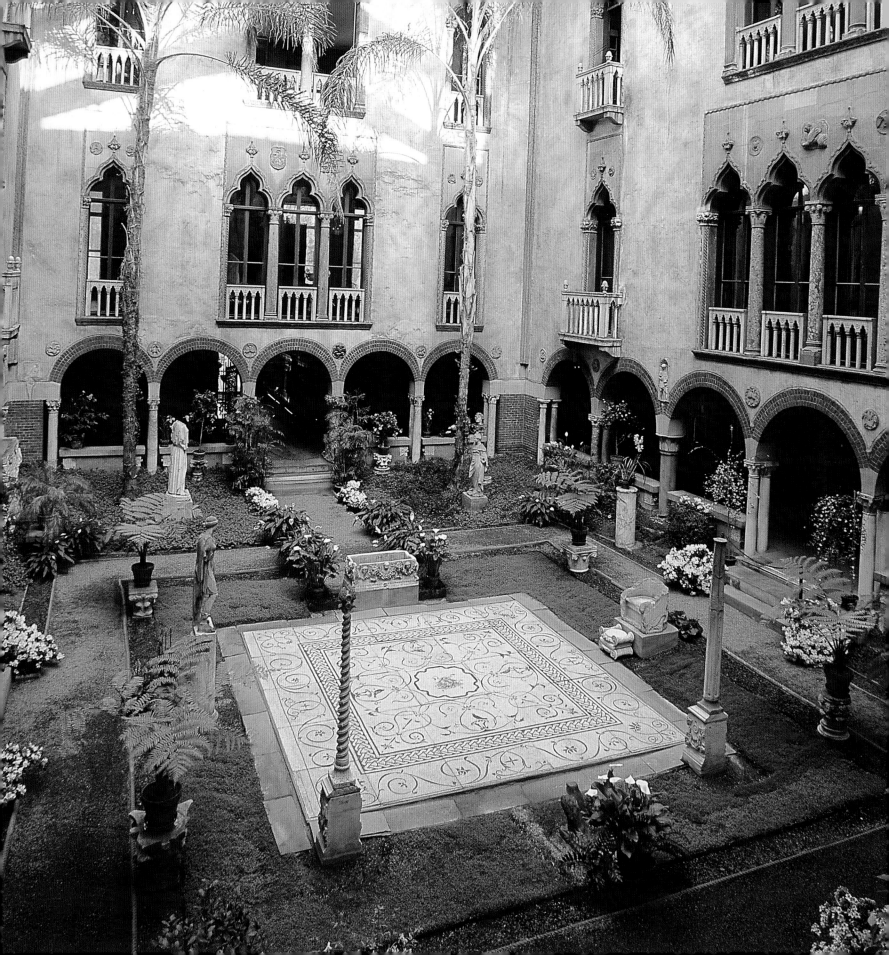

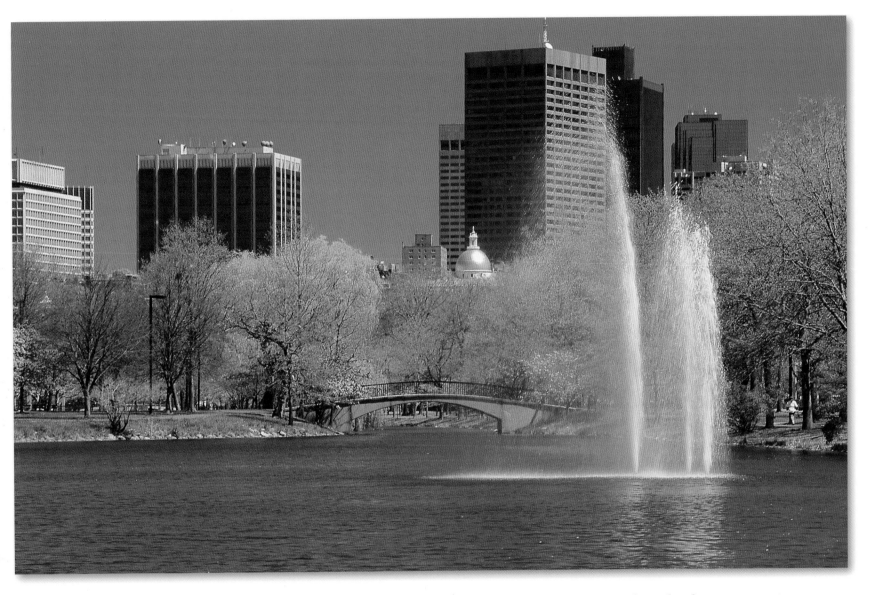

A series of locks ensures calm waters on the Charles River as it runs between Boston and Cambridge on its way to Boston Bay. The Cambridge River Festival, the Dragon Boat Festival, and many other events draw city dwellers to the river year-round.

Founded by Isabella Stewart Gardner in 1903, the Gardner Museum showcases an extensive collection of painting and sculpture by masters such as Botticelli, Rembrandt, Degas, and Matisse.

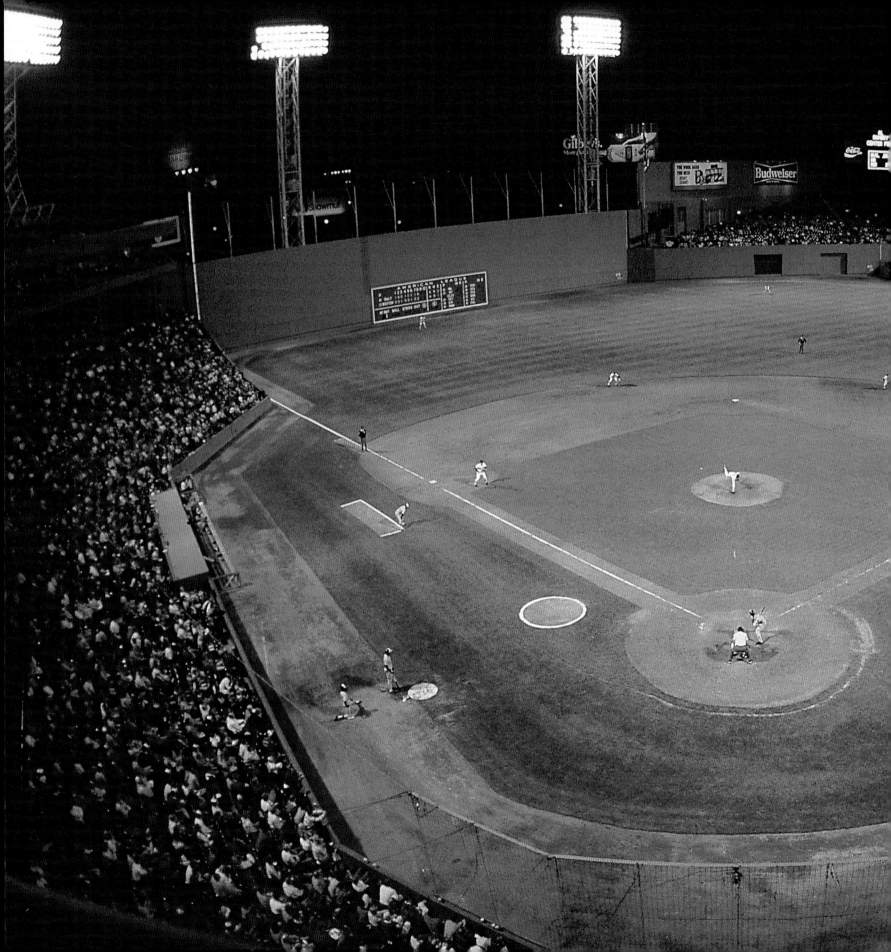

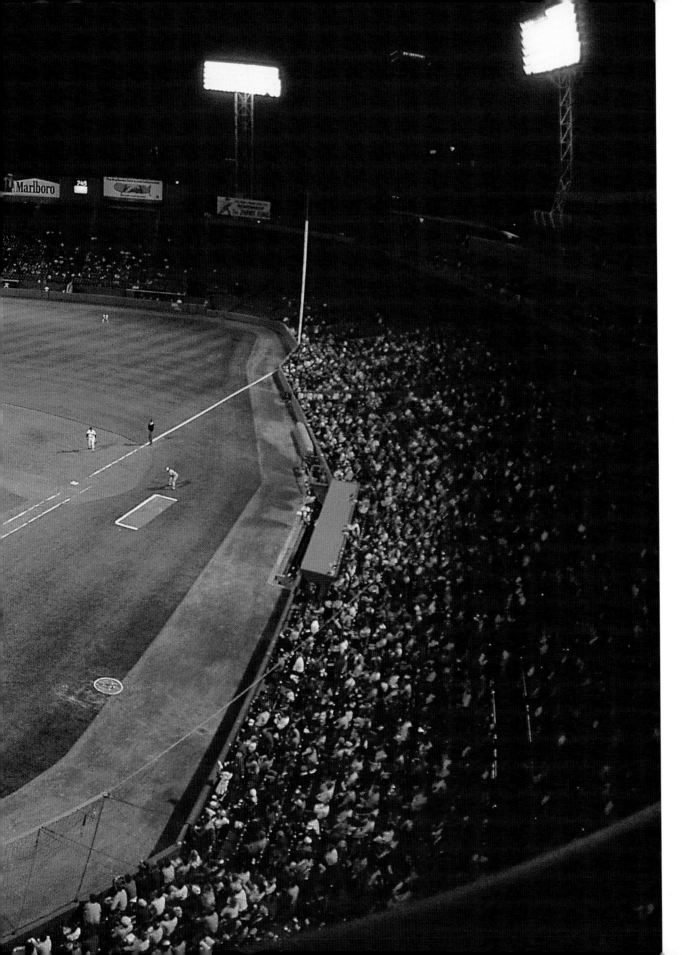

One of America's most famous baseball venues since it opened in 1912, Fenway Park is home to the Boston Red Sox, once the team of Babe Ruth. In 90 years, no player has ever hit a home run over the stadium's right-field roof.

Graphic designers,
new media gurus,
and traditional artists
live and work in
the lofts that line
Summer Street.

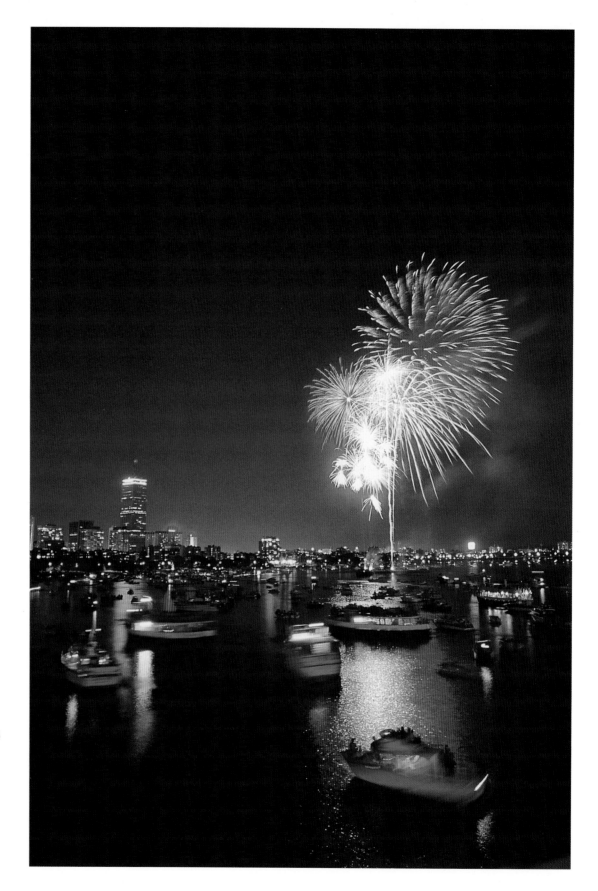

Fireworks burst over the harbor during the annual Fourth of July festivities. Each year, the pyrotechnics are timed to complement music performed by the Boston Pops Symphony.

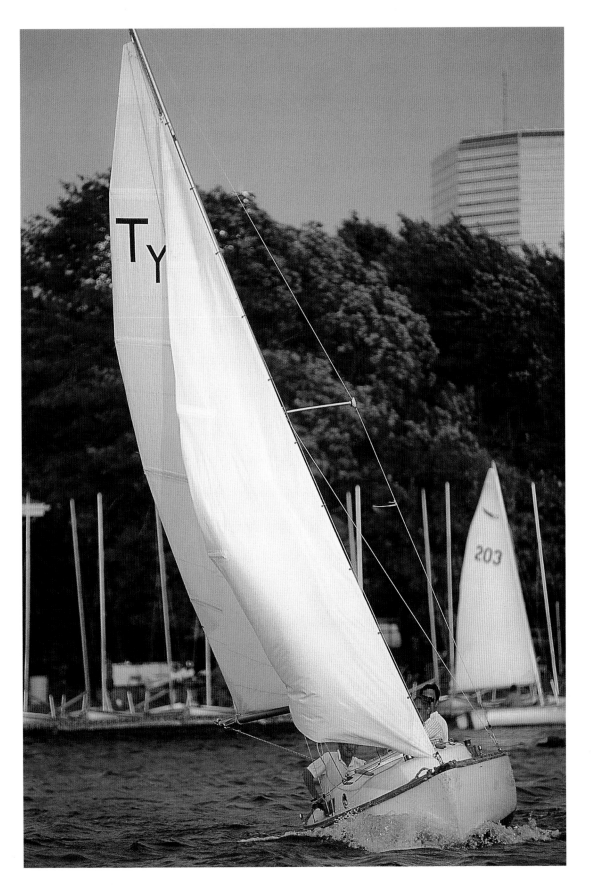

In the 1930s, Joseph Lee, Jr. founded a small learn-to-sail program on the Charles River to keep Boston's children busy during the summer. Today, his organization has become Community Boating, a nonprofit corporation with 6,500 members of all ages.

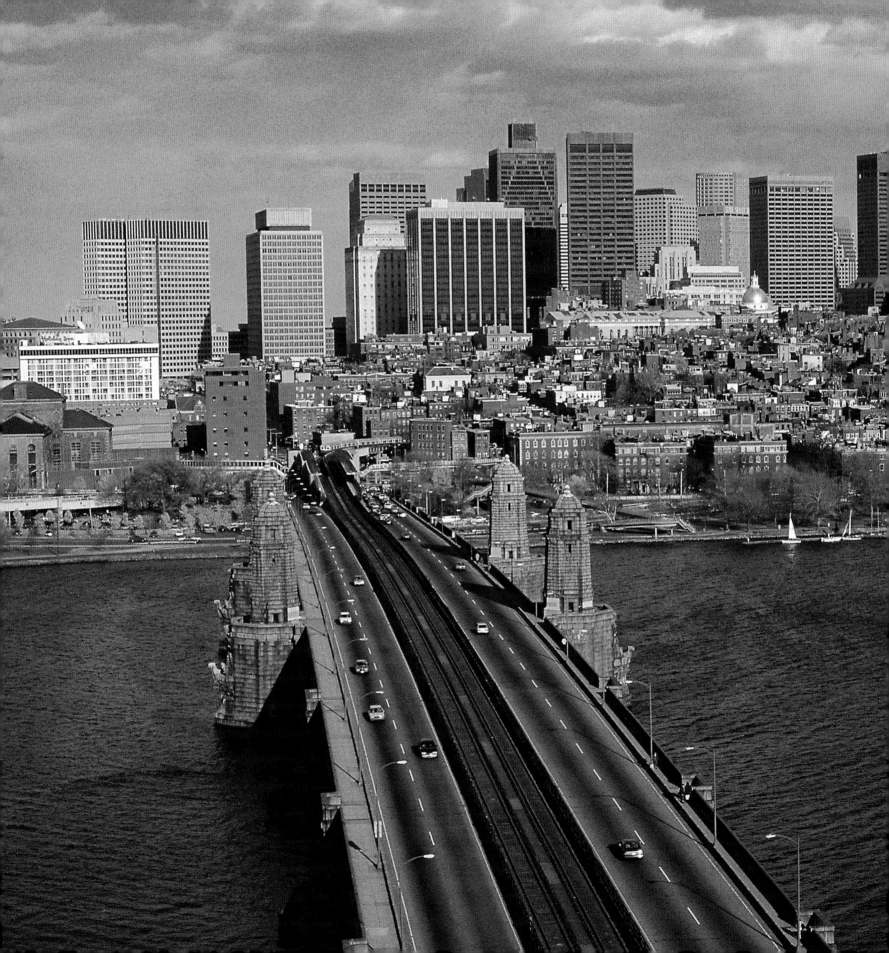

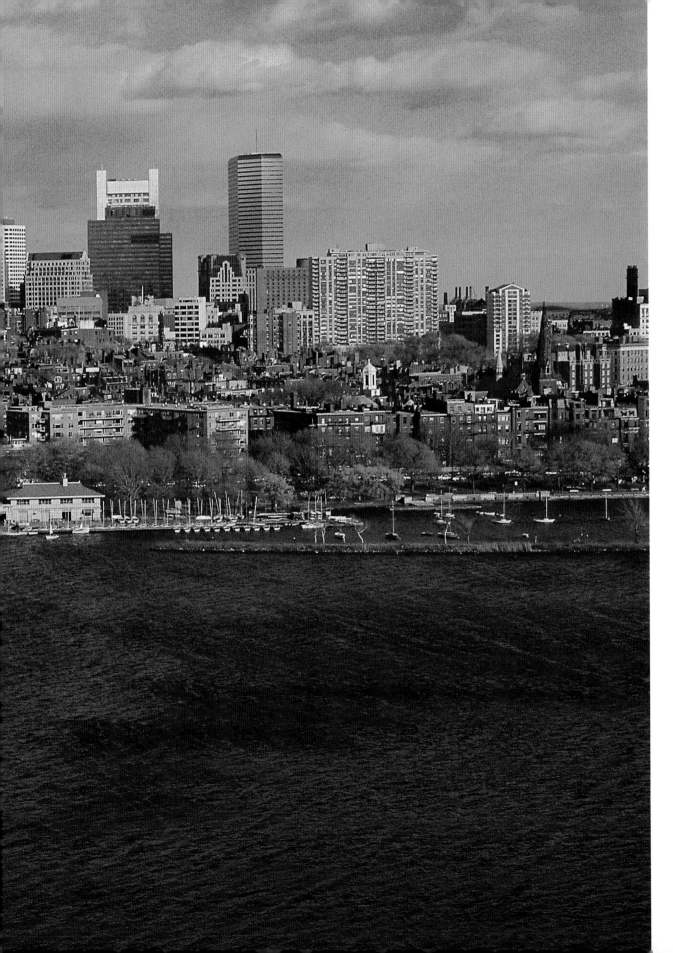

More than 1,700 feet long, the Longfellow Bridge spans the Charles River between Boston and Cambridge. Named for Boston resident Henry Wadsworth Longfellow, the bridge was built in the early 1900s by engineer William Jackson.

81

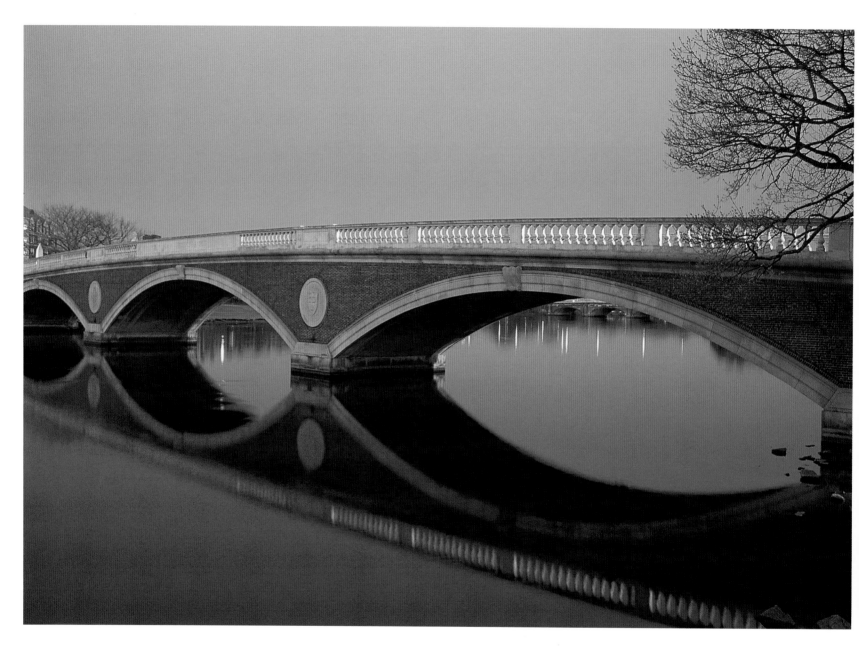

Just across the Charles River from Boston, Cambridge is a lively community of students and professionals. Harvard University, the Massachusetts Institute of Technology, and many high-tech companies are based within the city.

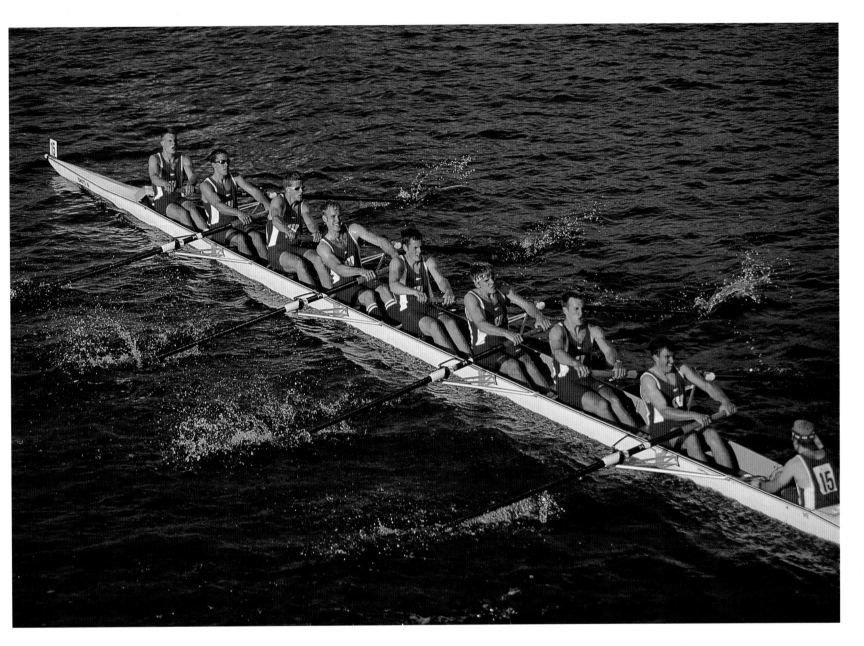

The Charles Regatta is held each October on the Charles River. The largest two-day rowing event in the world, it draws thousands of athletes and spectators. Winners claim the title "Head of the Charles."

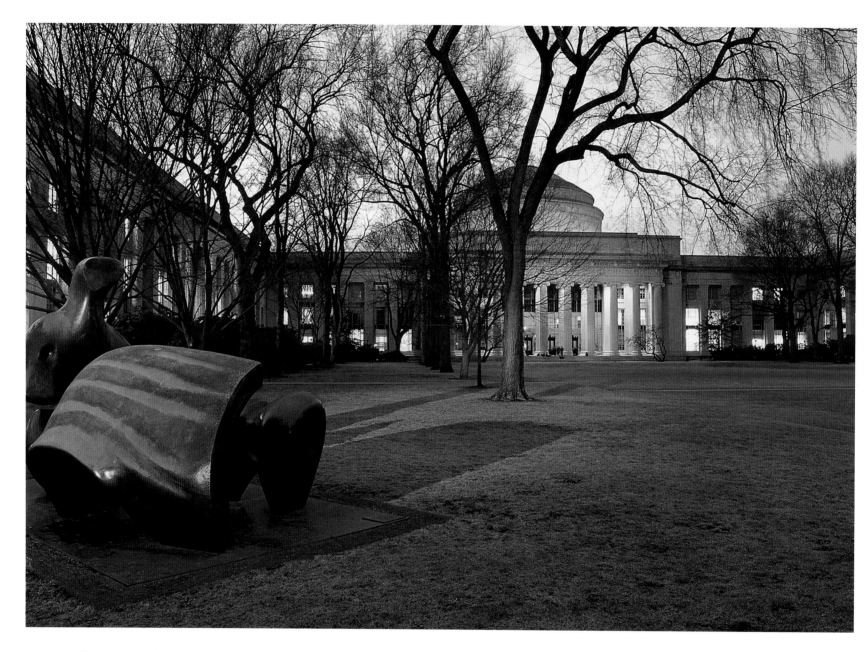

MIT—the Massachusetts Institute of Technology—was the brainchild of William Barton Rogers, a nineteenth-century natural scientist and a pioneer in teaching science through hands-on laboratory work. With more than 10,000 students, the school continues to foster innovative research and education.

America's first university, Harvard was founded in 1636 (only 16 years after the Pilgrims arrived). It is named for John Harvard, a minister who bequeathed half his estate and his collection of books to the school.

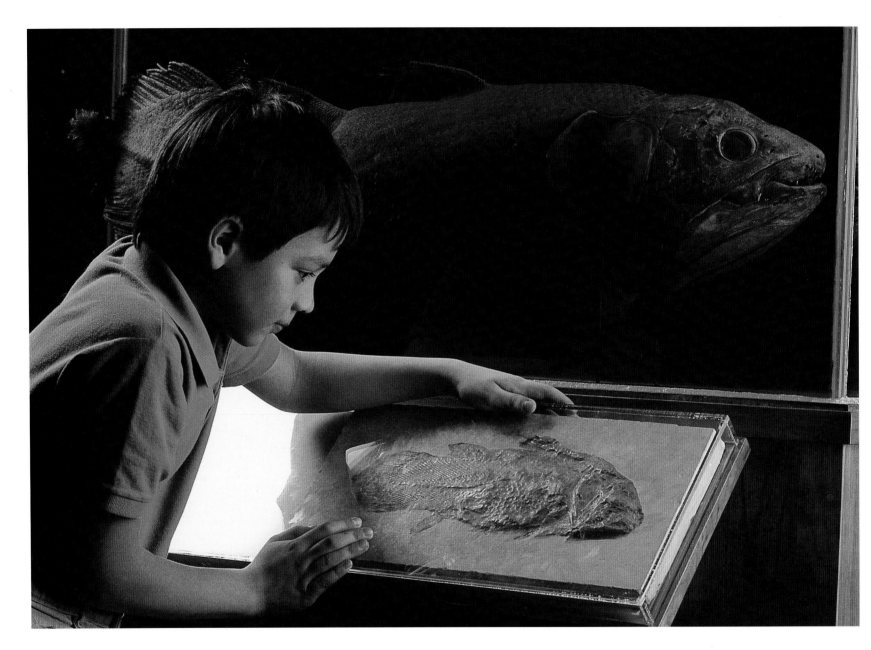

The very young examines the very old. At the Harvard Natural
Science Museum visitors can explore a wide variety of displays,
including Coelacanth fish fossils.

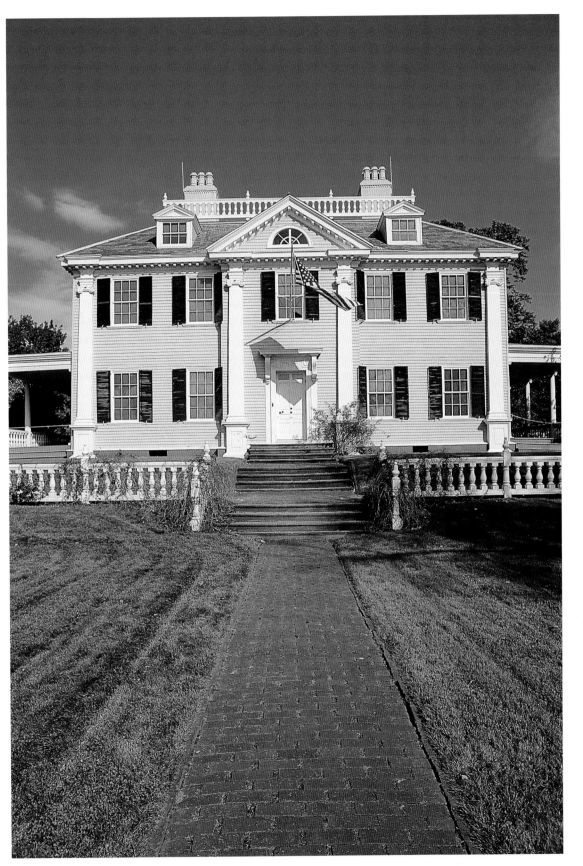

Henry Wadsworth Longfellow boarded in this Cambridge home while teaching at Harvard University in the 19th century. When he married, his father-in-law purchased the home as a wedding gift. It was here that Longfellow wrote many of his most famous poems.

Harvard Hall is the
second building to
stand over Harvard
Yard; the first burned
to the ground in
1764. According to
legend, a student
borrowed a book
from John Harvard's
personal collection,
and returned it after
the fire destroyed
all others like it. He
was thanked for sav-
ing the volume, then
expelled for borrow-
ing it without
permission.

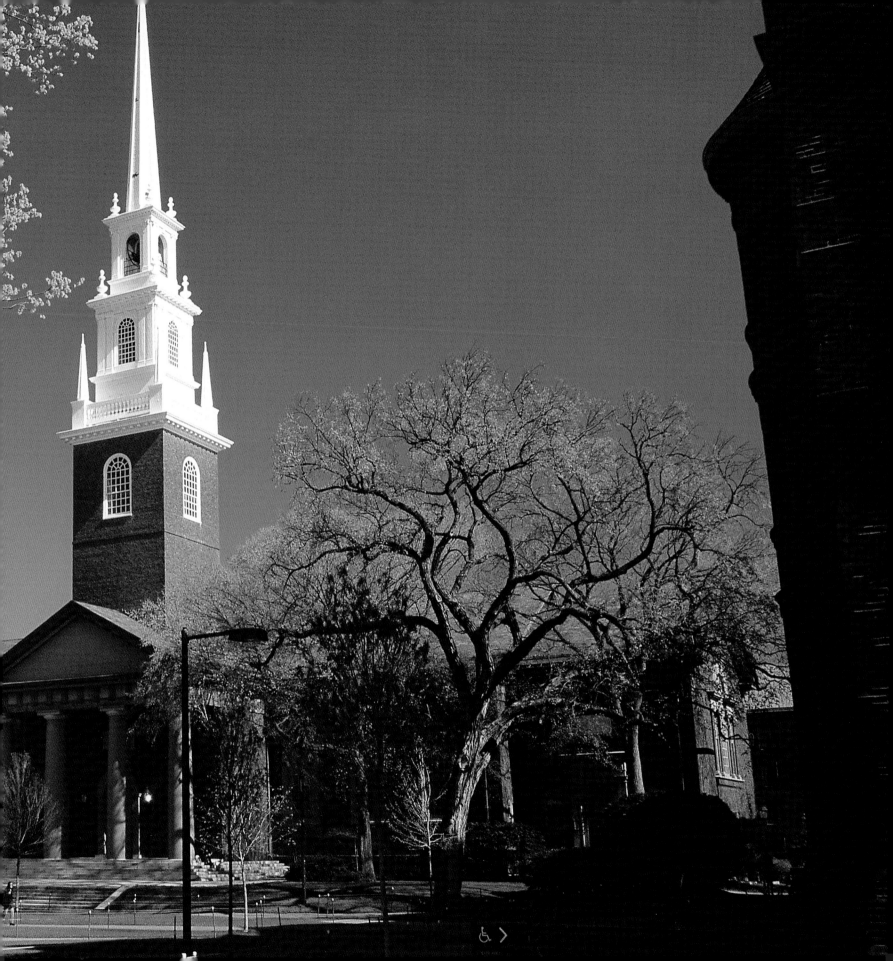

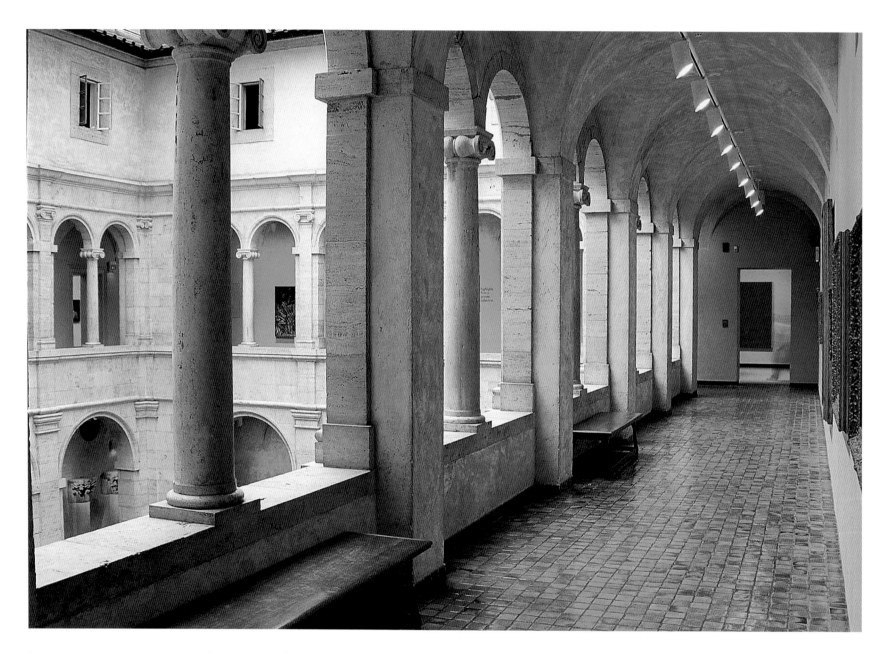

The oldest museum on the Harvard University campus, the Fogg
Art Museum has welcomed visitors since 1895. Its ornate galleries
trace Western art history from the Middle Ages to the present day.

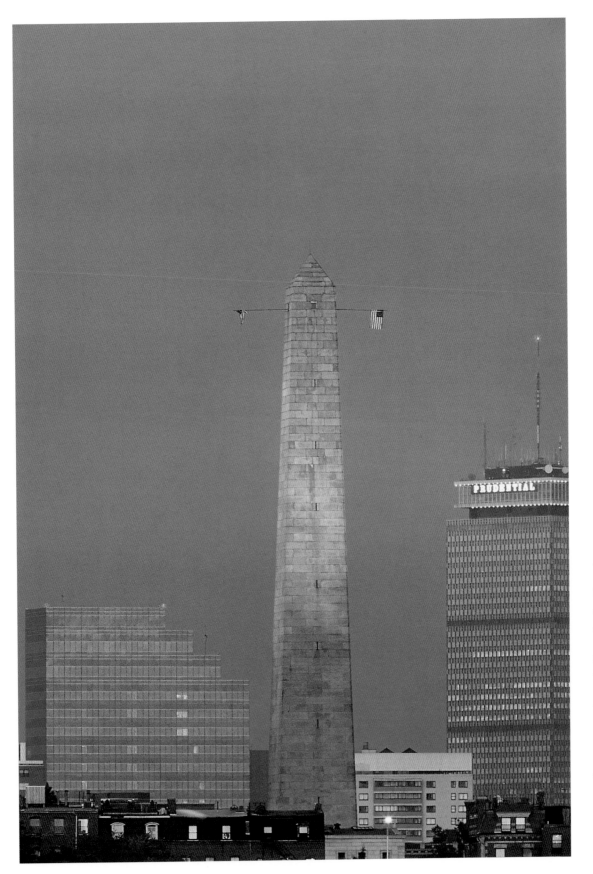

Visible just past the Boston skyline, the Bunker Hill Monument actually stands atop Breed's Hill. The revolutionary troops who spent the night building fortifications on June 16, 1775, had confused the hilltops.

91

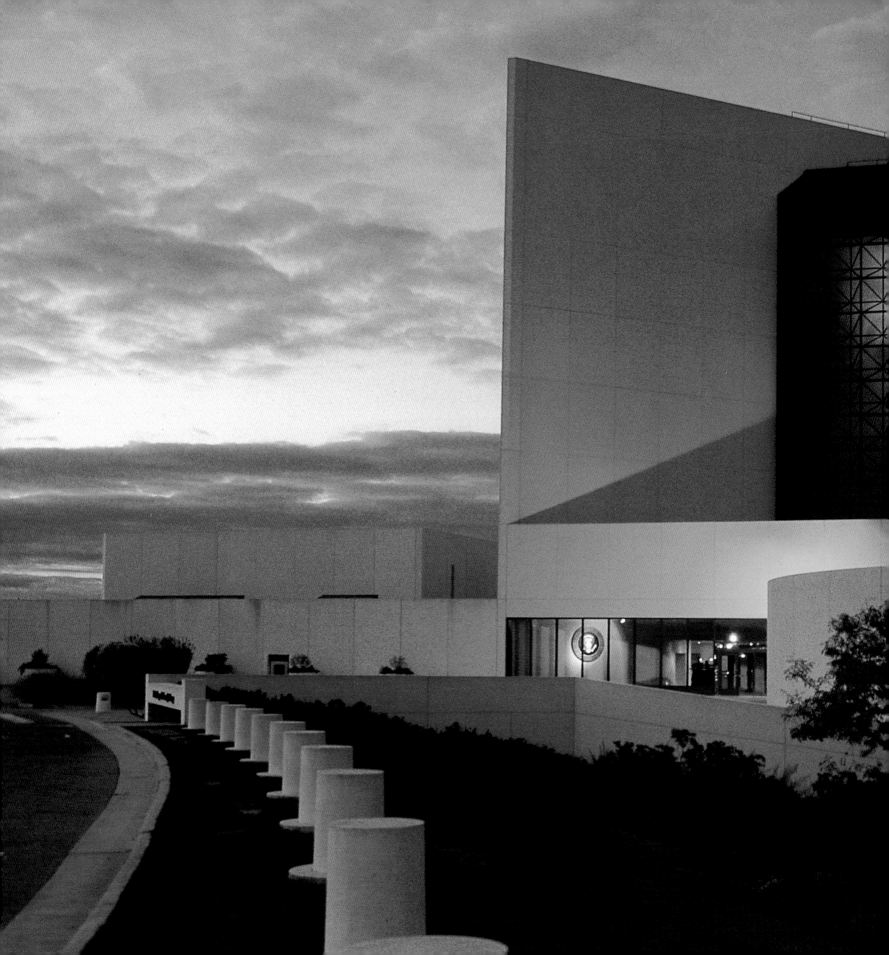

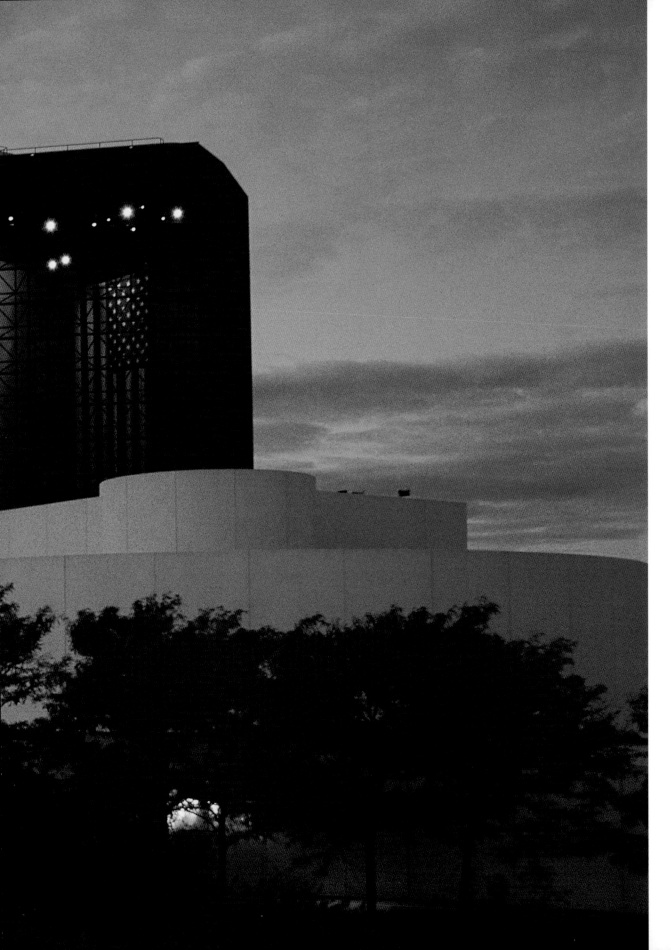

Designed by
I. M. Pei, the John
Fitzgerald Kennedy
Library and Museum
spirits visitors back
to the 1960s, when
JFK reigned in the
White House and
the Cold War threat-
ened. Exhibits recre-
ate scenes such as
the 1960 Democratic
Convention Hall and
the first Kennedy-
Nixon debate studio.

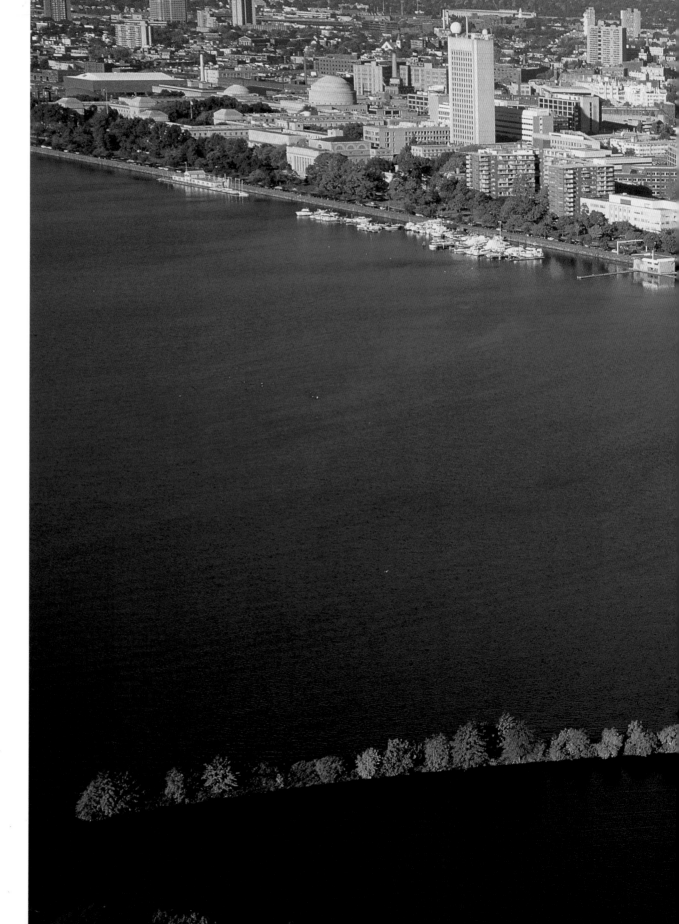

From antiques
shows and ballet
performances to
parades, jazz con-
certs, and kite-flying
competitions, sum-
mer events in Boston
keep visitors busy
from dawn until
well after dusk.

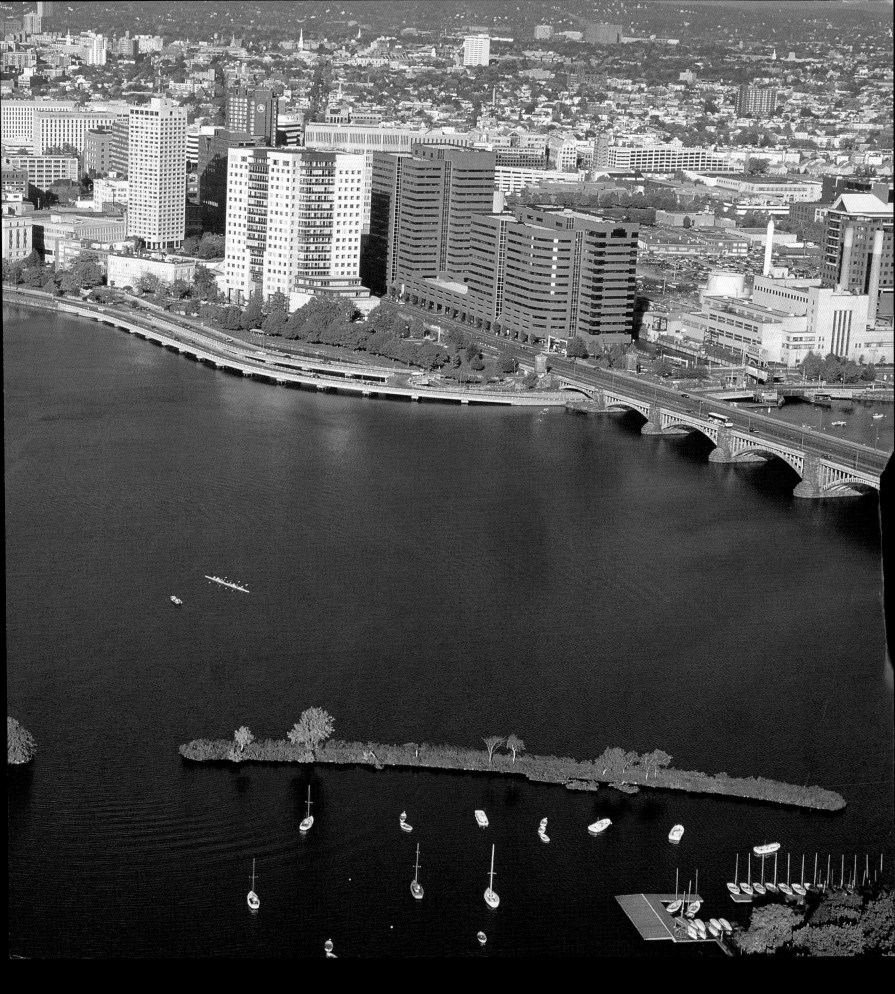

# Photo Credits